The Helsinki School
New Photography by TaiK

The Helsinki School
New Photography by TaiK

HATJE
CANTZ

Timothy Persons

The beauty of photography rests in its capacity as a process to capture the silent hunger that floats between the image and the concept that resides behind it….

…Deep within this silence we can listen for what our eyes can see, feeling for the image that fills the thought.

This book, *Helsinki School: New Photography by TaiK* is dedicated to sustaining that conceptual dialogue between one generation and another from those artists who have either taught, graduated, or attended the University of Art and Design Helsinki, Finland. These conversations are more than just the exchanging of words, ideas and positions. It represents a search for questions and answers, the sharing of experiences to create and realize new ways to conceptualize how we see, feel, and wear the world we live in.

One of the primary goals of any education system is to develop new approaches regarding how to climb the tower of information. The challenge is to create situations where the harvesting of experience transforms itself into a living knowledge.

To do this the University of Art and Design through its Professional Studies program conceived Gallery TaiK in the mid nineteen-nineties. As a site-specific gallery its primary aim was to open up new opportunities for those selected artists to exhibit their works abroad. To realize this, Gallery TaiK began participating in several selected international art fairs, specifically Art Forum Berlin and Paris Photo. This enabled a forum to be established to present as well as to reference from, creating a transient classroom. The balance between theory and reality is to taste the ordeal of doing. Thus, the "Helsinki School" was born.

Its path to the present has been built one step at a time. Combined together these steps resonate a strong conceptual sound that echoes through four generations, each with their own voice.

I would like to express my gratitude to the University of Art and Design for its endless support and to all those involved in this project for helping it find its feet in the darkness of doubt. And special thanks to Dr. Pentti Kouri who helped me and many others find their feet wherever they landed.

This latest publication will accompany an ongoing international exhibition tour that began in 2004. Each venue has a new selection of photography and videos highlighting those artists from each generation with their most current work.

▷ *Timothy Persons is Director of Professional Studies at the University of Art and Design Helsinki (UIAH), one of the largest universities for the arts in Scandinavia.*

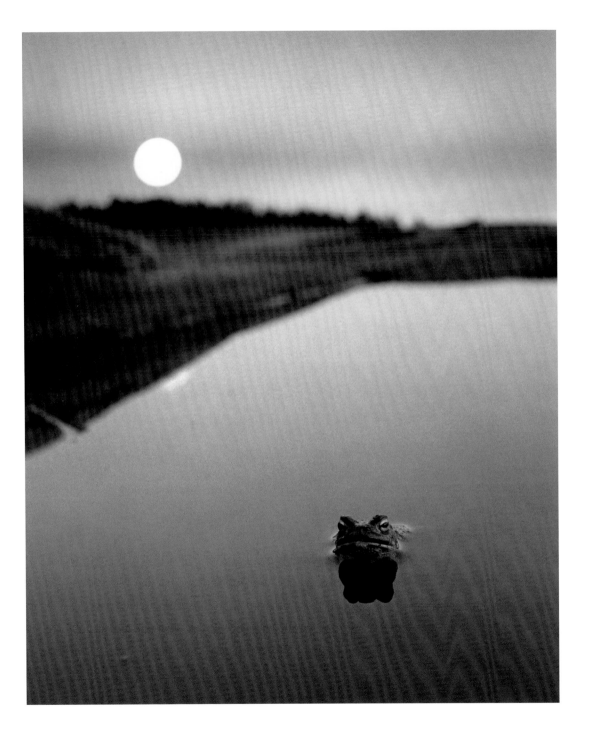

Ristisaari, Finland, 1974, 30 x 26 cm, gelatin silver print

Pentti Sammallahti

Pentti Sammallahti is one of Finland's most important photographers. He was a teacher…

…at the University of Art and Design in Helsinki before obtaining, in 1991, a grant from the Finnish government, which allowed him to give up teaching and concentrate entirely on his work. Sammallahti works within the classical black-and-white tradition of photography.

As a photographer he is not interested in events but, rather, in the places to which he travels and the people whom he encounters. His approach is influenced by Henri Cartier-Bresson, from whose work he adopted the idea of the decisive moment, meaning the ability of photography to capture a unique moment in the flux of time, and the importance of harmony and balance in the composition of a picture. Recording his surroundings, he has traveled through countries like Iceland, Lapland, Russia, Nepal, or Japan, favoring those with cool climates similar to Finland.

As a photographic globetrotter, Sammallahti leaves the beaten track in order to photograph remote locations, places where people still live in close contact with nature. While maintaining a distance which is both respectful of his subjects and necessary in order to capture any given scene, Sammallahti succeeds in imbuing his photographs with a sense of lyrical intimacy.

Possessed of a profound sense of humor, he is fond of taking pictures of animals with comical behaviors or in amusing situations. Sammallahti has a special relation to man's best friend and many of his photographs are extremely entertaining pictures of dogs engaged in living out their doggie lives.

A great lover of nature, Sammallahti often combines the landscape with his portraits of people and animals. But he also pays tribute to nature's beauty in remarkable, highly contemplative landscape photographs. ▷ *Pentti Sammallahti was born in 1950 in Helsinki, Finland. He was a teacher of photography at the University of Art and Design Helsinki from 1974 to 1991.*

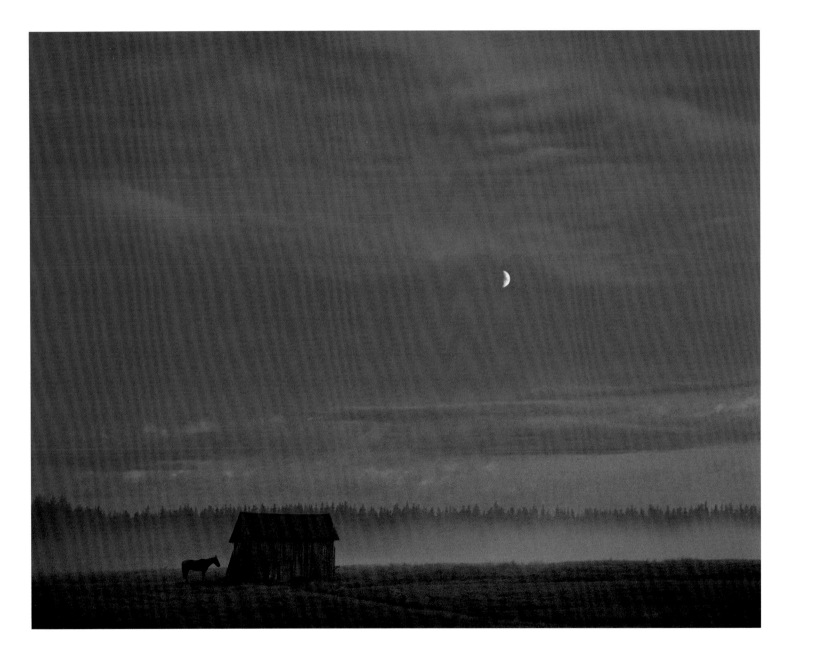

Pentti Sammallahti

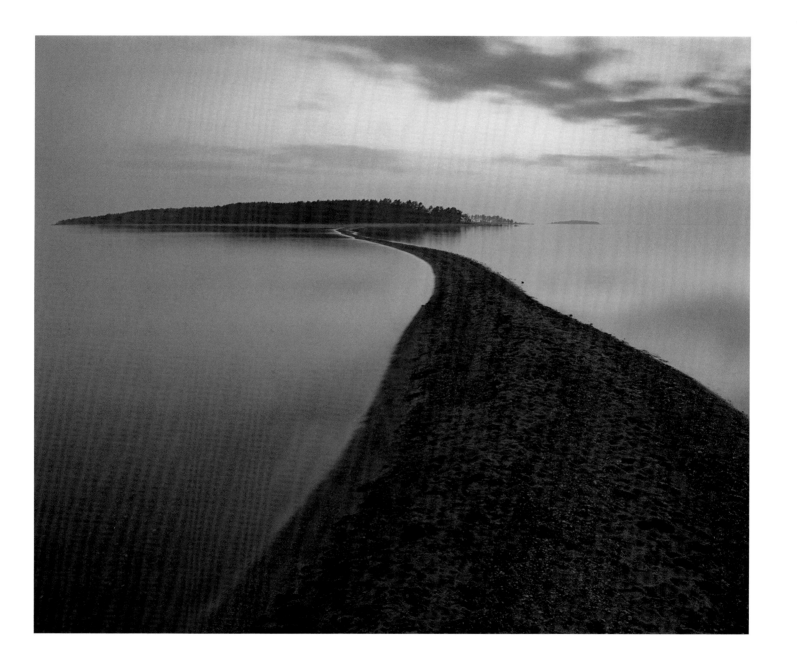

Sandö, Finland, 1975. 36 x 45 cm, gelatin silver print

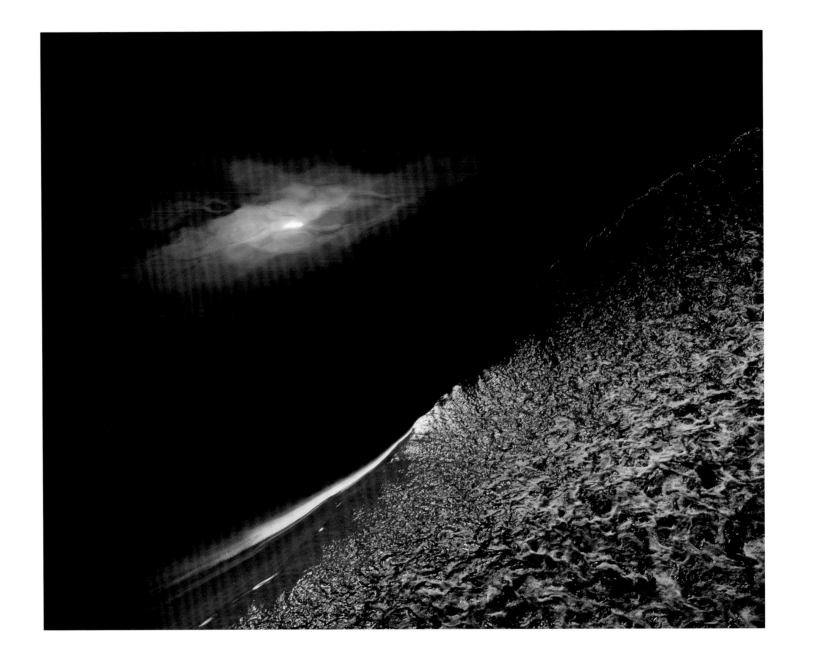

Pentti Sammallahti

Airisto, Finland, 1978, 26 x 34 cm, gelatin silver print

Pertti Kekarainen studied sculpture before starting his career as a photographer. Combining his interests as a sculptor…

…with photographic techniques, Kekarainen concentrates primarily on the subject of space, particularly the question of how to integrate three-dimensionality onto the flat surface of a photograph. To demonstrate this question of space and make it manifest to the viewer, it became necessary for Kekarainen to invent a special technique that integrates both in-focus and out-of-focus, hole-like elements onto the surface of the photograph. These holes create the impression that the image is situated behind a veil or a semi-transparent surface. In his early series *Density* from 1995 to 2001, mostly featuring interiors, Kekarainen's treatment of the subject precludes emotional involvement, focusing exclusively on these formal explorations.

In his recent series *Tila* (meaning "space," "place," "area," "room," or "state of mind") started in 2004, Kekarainen continues his approach, creating more and more complex spaces through the introduction of new formal elements. ▷ *Pertti Kekarainen was born in 1965 in Oulu, Finland. He has been a professor at the Academy of Fine Arts in Helsinki since 2002 and a visiting lecturer at the University of Art and Design Helsinki since 2001.*

Pertti Kekarainen

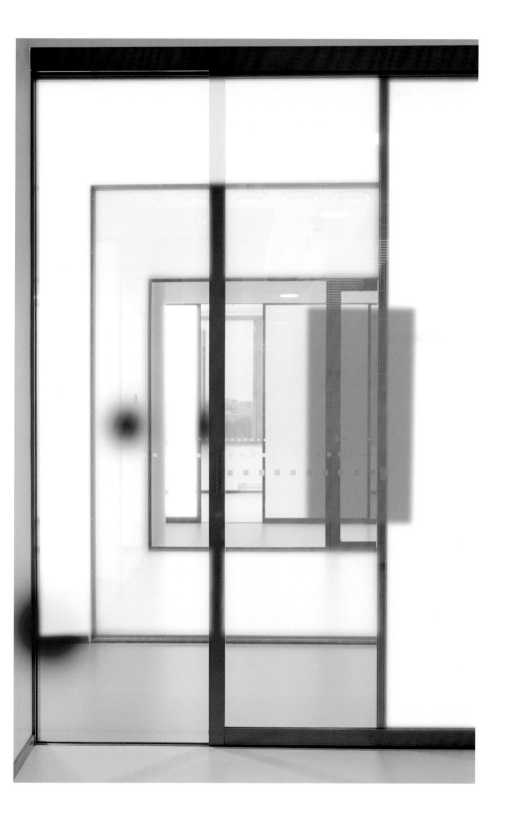

TILA (passage I), 2006, 195 x 125 cm, c-print/diasec

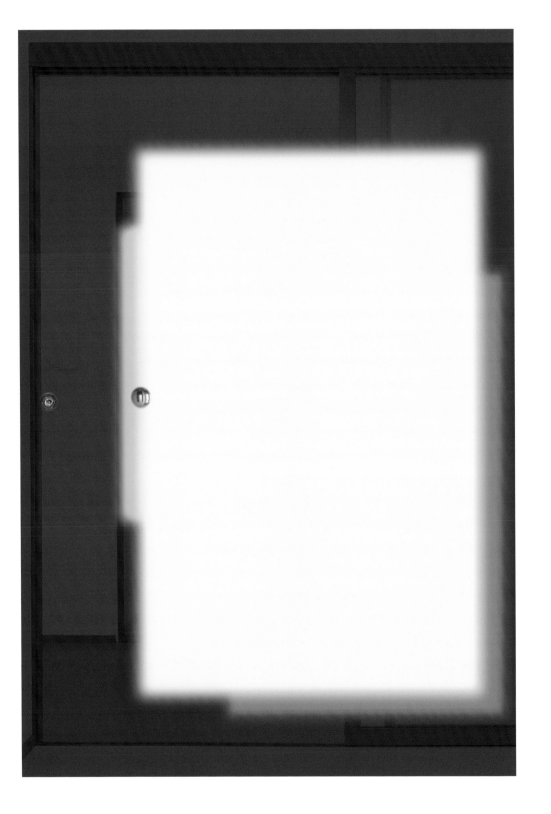

TILA (red angle I), 2005, 195 x 130 cm, c-print/diasec

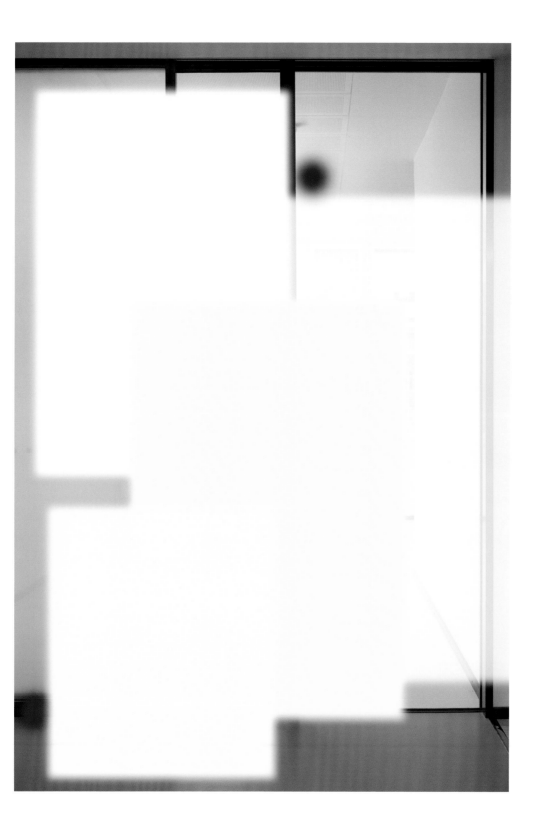

TILA (transparent), 2006, 195 x 140 cm, c-print/diasec

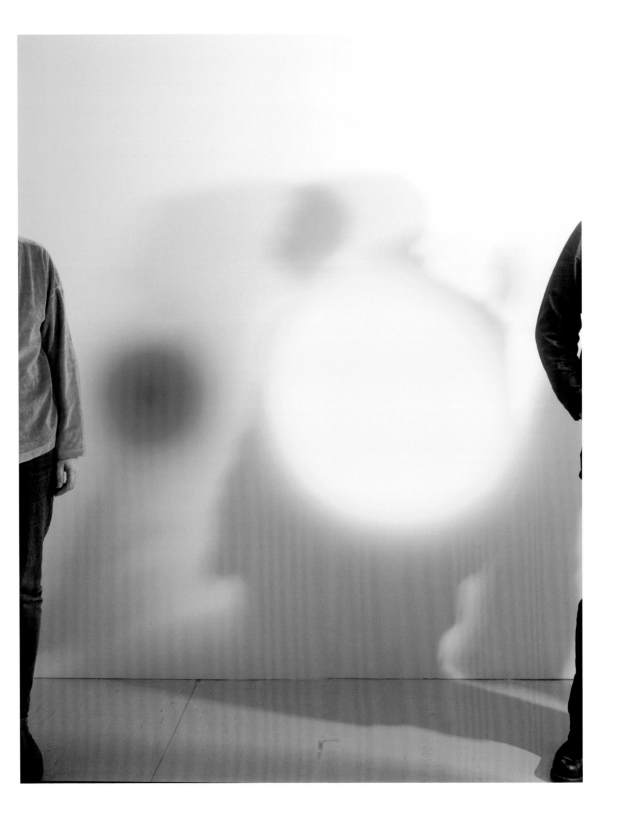

TILA (green dot), 2005, 60 x 46.5 cm, c-print/diasec

Pertti Kekarainen

TILA *(moving dots)*, 2005, 60 x 48 cm, c-print/diasec

Nanna Saarhelo

Nanna Saarhelo's series
Imagined Landscapes
is based on her personal
experiences while living
in Barcelona and traveling
in Catalonia and to the
Balearic Islands in 2005....

…In *Imagined Landscapes* Nanna Saarhelo combines and juxtaposes images of landscapes with photographs of a more intimate genre. In presenting her photographs in groups of diptychs or triptychs, the artist introduces a narrative component. However, instead of telling the "real story," Nanna Saarhelo composes new relations by combining images, not in a geographical or chronological order, but by creating associations between them in a purely poetic manner. Unlike the work of, for example, Maarit Hohteri, which is anchored in the tradition of the autobiographical recitation, Nanna Saarhelo uses the fragments of her life, and her surroundings, to create a whole new story, a different life. The artist does not relate real events, what she really experienced during her travels, but instead supplies the viewer with bits and pieces of her memory without conveying a specific message. Concerning her work Nanna Saarhelo states: "My intention is not to create a puzzle for the viewer to solve, but rather, to create work which is formed by a jungle of signs and symbols that aim to awaken personal interpretations." ▷ *Nanna Saarhelo was born 1977 in Espoo, Finland. She graduated as a Bachelor of Arts from the Surrey Institute of Art & Design, England, in 2000.*

Nanna Saarhelo

From the series *Imagined Landscapes*, 2005, 111 x 35 cm, c-print

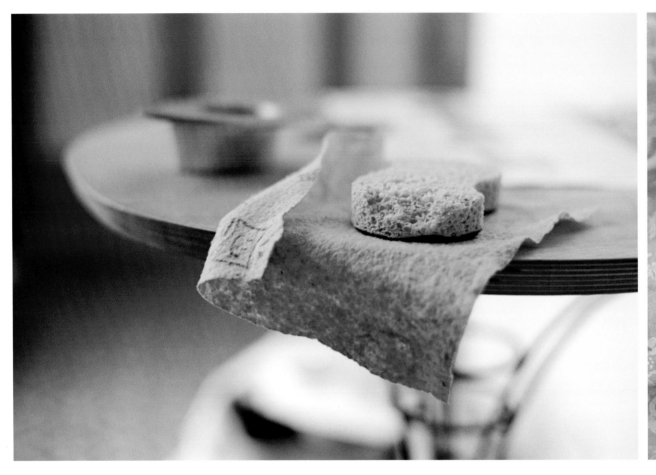

From the series *Imagined Landscapes*, 2005, 127 x 26 cm, c-print

From the series *Imagined Landscapes*, 2005, 80 x 26 cm, c-print

From the series *Imagined Landscapes*, 2005, 75 x 53.8 cm, c-print

Before studying photography,
Ville Lenkkeri studied film
at the Academy of Performing
Arts, FAMU, in Prague,
and at the National Film and
TV School in London.
Cinematography and film
remain strong influences…

…in his artistic approach and his photographic subjects refer to the moving image. In one of his first series, *Movies*, started in Prague in 2001, Lenkkeri explored the correlation between cinema and photography, through the use of time.

If photography was the precursor of the moving image, cinema has influenced photography by causing it to move away from the simple reproduction of reality and by demonstrating its ability to create fictions. In his recent series *Reality in the Making*, Lenkkeri uses some of cinema's artifices in photographing existent scenery or settings which confound reality and fiction by producing fake realities and real fictions. Lenkkeri photographs the real, but the reality he photographs is often a fiction, such as dioramas in a history museum or a museum of natural history, or frescoes in a restaurant or hallway. The presence of a living person, such as a weary museum guard, adds to the ambiguity of some of his scenes. It is difficult to know whether his protagonists are in the picture because they belong in these strange settings or whether they have been introduced as actors. The ambiguity pervading Lenkkeri's photographs provokes doubt about what one is seeing and leaves the viewer suspended between belief and disbelief. ▷ *Ville Lenkkeri was born in 1972 in Oulu, Finland. He graduated from the University of Art and Design Helsinki in 2006.*

Ville Lenkkeri

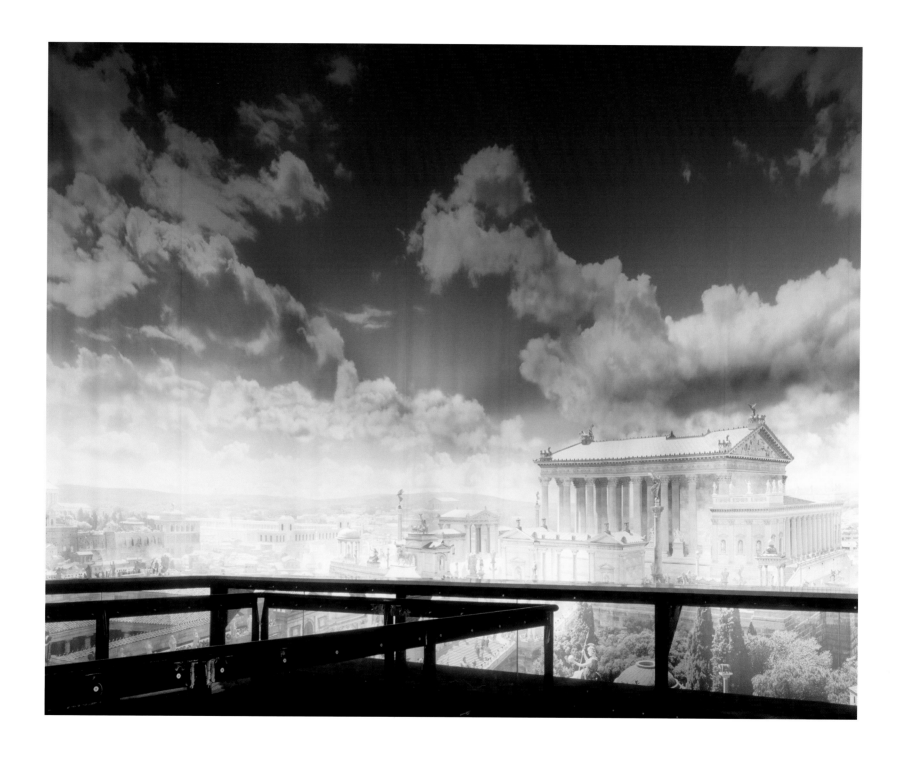

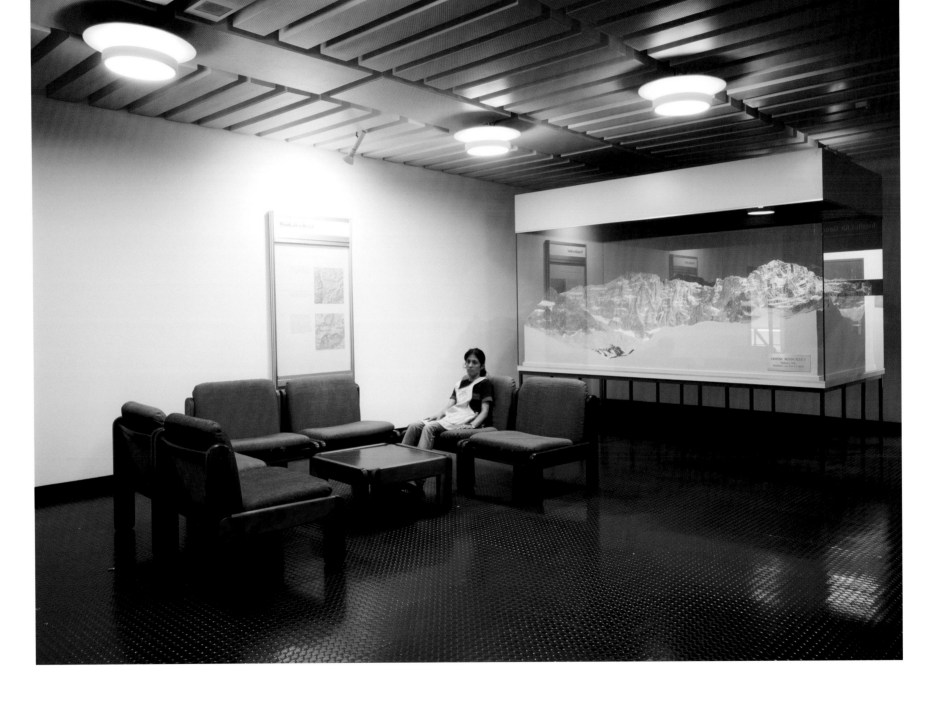

Switzerland, Zurich, 2002, 90 x 120 cm, c-print/diasec

The Months Before Birth (Stillborns), Rouen, 2004, 90 x 120 cm / 120 x 160 cm, c-print/diasec

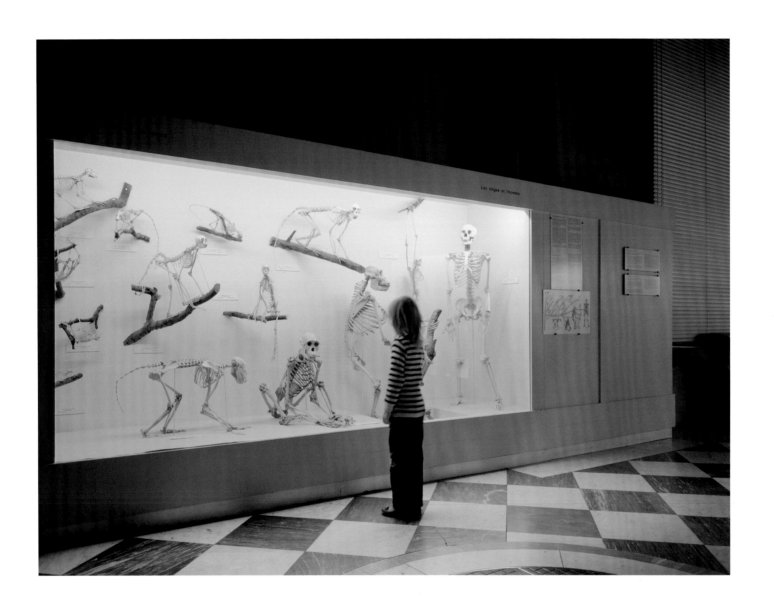

Monkeys and Man, Brussels, 2003, 90 x 120 cm, c-print/diasec

From the series *My Unopened Letters*, 2006. 103 x 179 cm, c-print

Jari Silomäki

Jari Silomäki's work
uses documentary techniques
to serve inspired visual
fictions and is based largely
on his personal experience....

…His early works, such as *Rehearsals for Adulthood*, a series of self-portraits depicting a figure in the fragile phase between adolescence and adulthood, are often constructed like photo romances. In a later series entitled *My Weather Diaries*, Silomäki linked his photographs to a written comment based on either a personal experience or an international event which occurred on the same day that the photograph was taken.

All of Silomäki's series have a strong narrative quality to them. Instead of the clichéd "decisive moment," the diary-like sequences of photographs serve as telling interludes in a personal narrative; moments that imply what came before and what is to follow.

The new series, *My Unopened Letters*, from 2006, is strictly in line with Jari Silomäki's previous artistic approach and his interest in the narrative and the personal. The title of the series suggests the content of the work: a collection of unopened correspondence between the author and people with whom he was connected in the past. The letters are metaphors for moments long gone, they enclose in their sealed envelops memories not yet digested.

Silomäki's photographs are possible scenarios of past events combining, as usual, photography with writing. The series bears a rather melancholic note and testifies to the narrator's attachment to his long past adolescence. ▷ *Jari Silomäki was born in 1975 in Parkano, Finland. He is currently a Masters Student at the University of Art and Design Helsinki since 2002.*

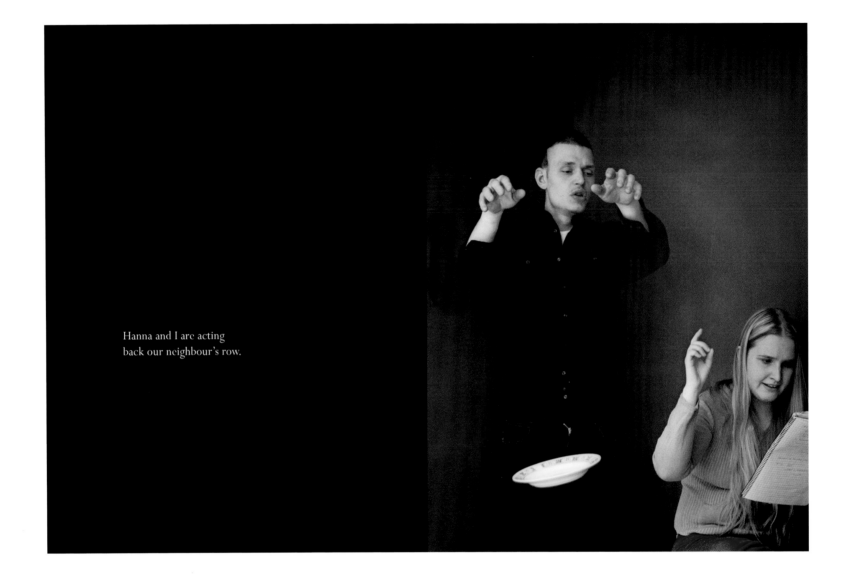

Hanna and I are acting
back our neighbour's row.

From the series *My Unopened Letters*, 2006, 16.5 x 24.5 cm, c-print

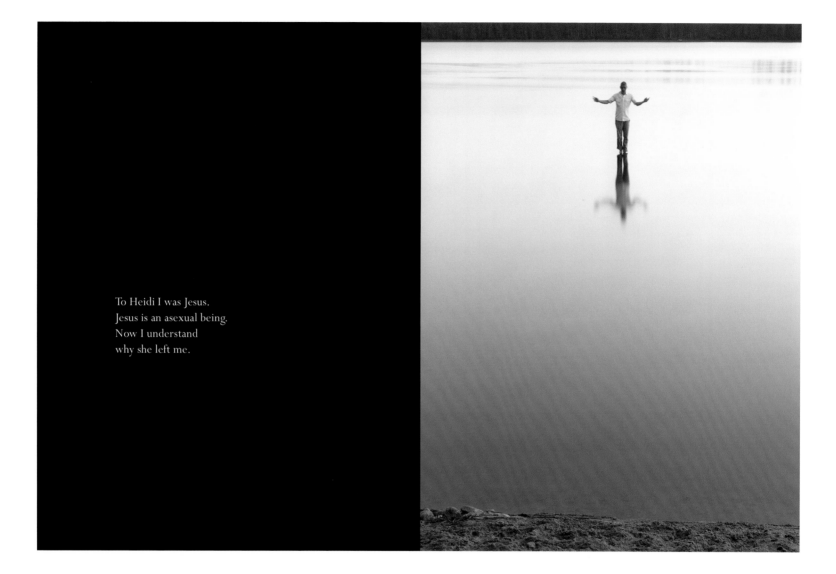

To Heidi I was Jesus.
Jesus is an asexual being.
Now I understand
why she left me.

From the series *My Unopened Letters*, 2006, 16.5 x 24.5 cm, c-print

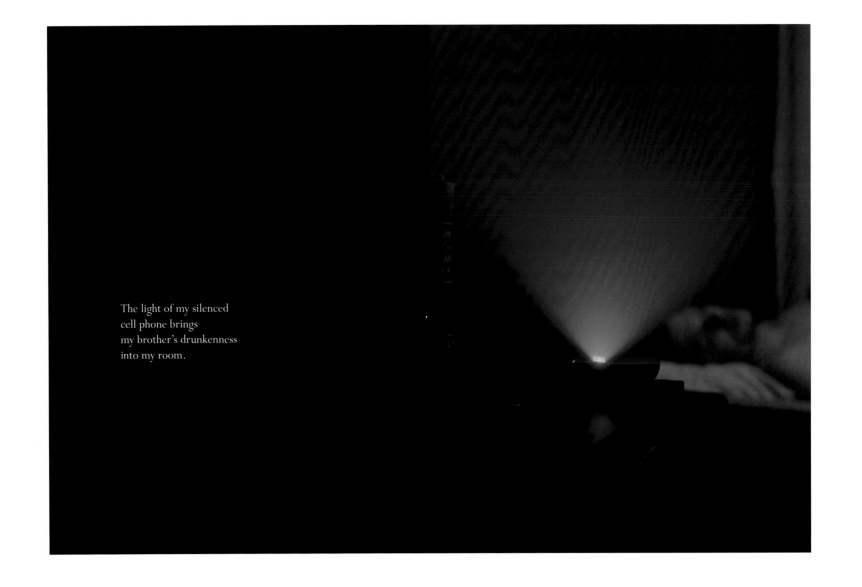

The light of my silenced
cell phone brings
my brother's drunkenness
into my room.

From the series *My Unopened Letters*, 2006, 16.5 x 24.5 cm, c-print

I met stranger in the forest.
She gave me lingonberries.

Jari Silomäki

From the series *My Unopened Letters*, 2006, 16.5 x 24.5 cm, c-print

Noomi Ljungdell's photographs are meditations on the rituals and automatisms which rule our lives….

…The starting point of her project, *Journey*, was the sudden awareness of the routines the artist had developed in going about her home town. She became fascinated by the repetition of her movements and started to repeat the routine intentionally, trying to use exactly the same routes over and over again.

Noomi Ljungdell states: "The habit or tradition of taking the same roads became a ritual, even meditation for me. The repetition underlined my existence. The continuity of the act made me more present in general, more aware that I was, I am, and I will be."

In her photographs Ljungdell represented this repetitive methodology by drawing the pattern of her "ritual routes," over and over again, with a light, on a street map. In *Journeys* she examines her movements in relation to a place, paying attention to where she went and where she didn't, as well as what kind of visual patterns her movements would form if drawn on the map. Both series express a certain melancholia, an existential loneliness, which convey the artists subjective experience. ▷ *Noomi Ljungdell was born 1979 in Helsinki. She graduated as a Bachelor of Arts from the University of Art and Design Helsinki in 2004 and is now studying for her Master of Arts degree.*

Noomi Ljungdell

Noomi Ljungdell

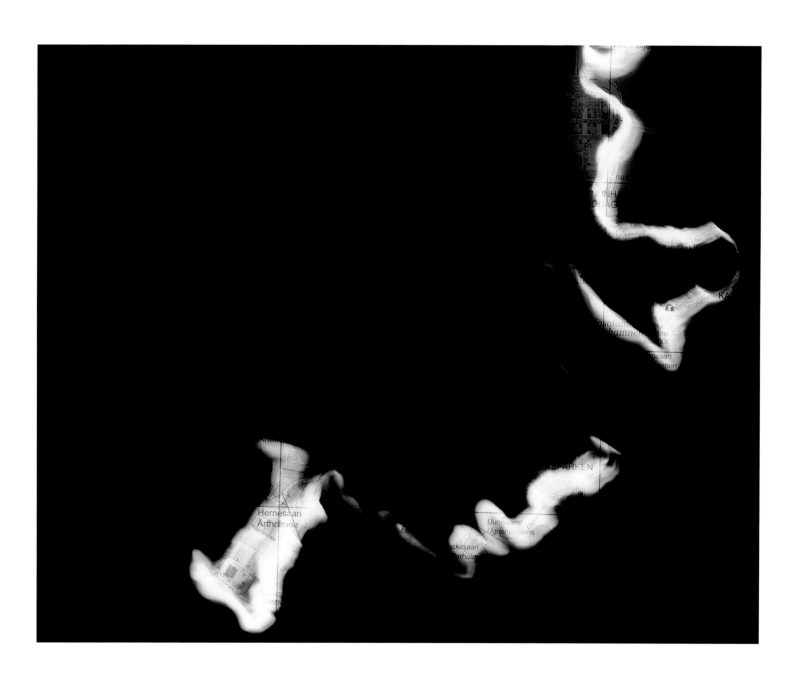

untitled III from the series Journey, 2004, 36 x 44 cm, c-print/diasec

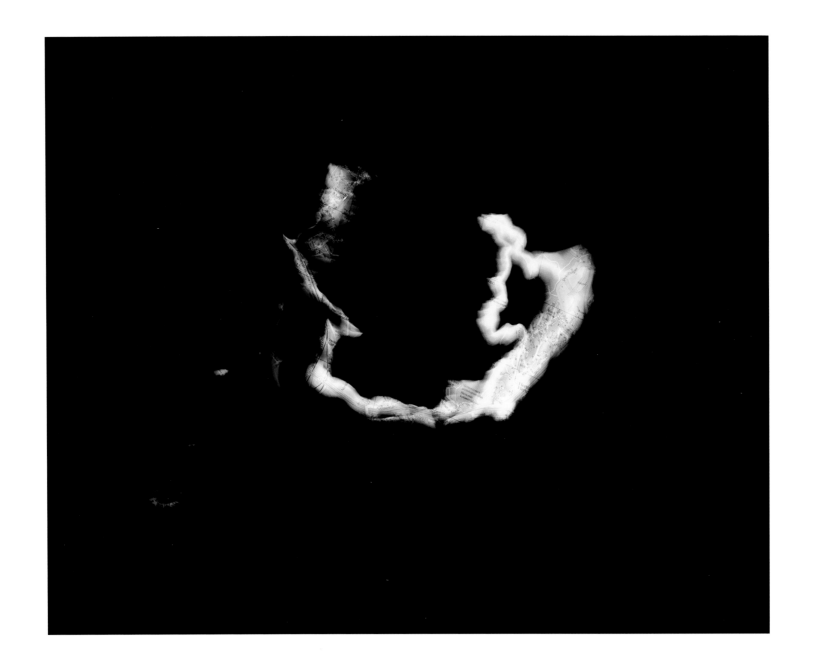

untitled IV from the series *Journey*, 2004, 36 x 44 cm, c-print/diasec

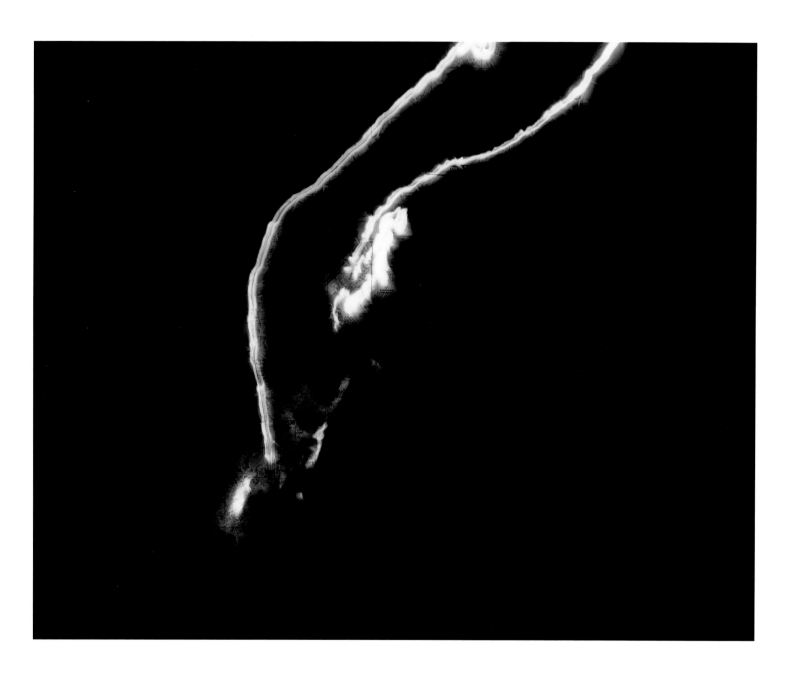

untitled I from the series *Journey*, 2004, 36 x 44 cm, c-print/diasec

One Thousand Steps on a Bridge from the series *About Distance and Light*, 2004, 37 x 46 cm, c-print
One Thousand Steps in a City from the series *About Distance and Light*, 2004, 37 x 46 cm, c-print

One Thousand Steps In a Forrest from the series *About Distance and Light*, 2004, 37 x 46 cm, c-print
One Thousand Steps On a Shore from the series *About Distance and Light*, 2004, 37 x 46 cm, c-print

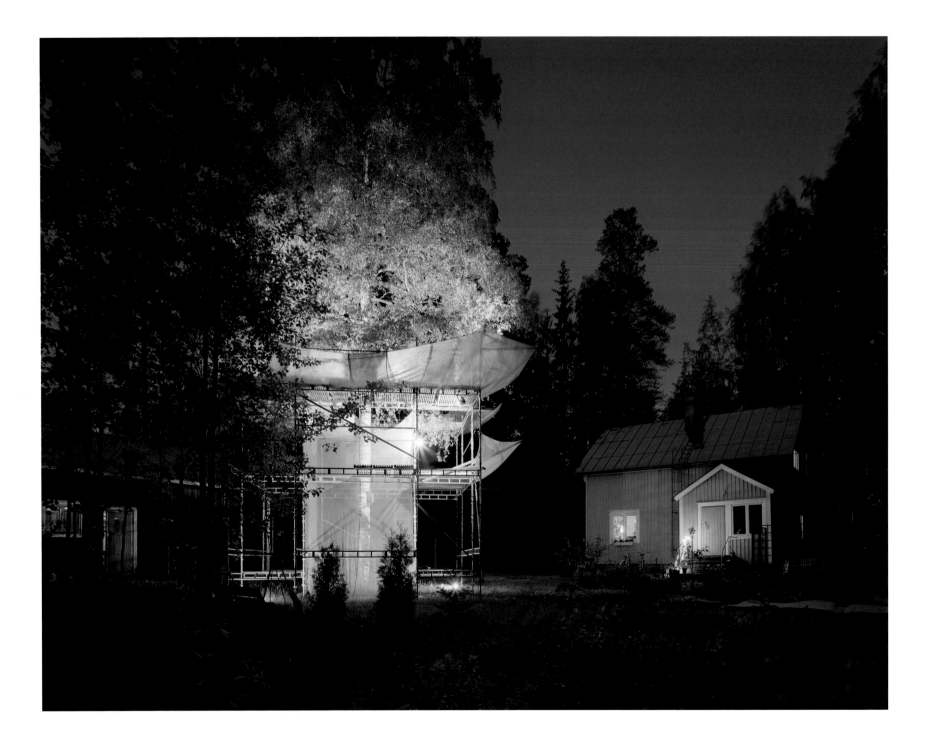

Restoration 12, 2005, 100 x 130 cm, c-print/aluminum

Ilkka Halso

Mankind's relationship to nature is the central theme of Ilkka Halso's large, lush, and meticulously constructed photographs.…

…*Restoration* is a series of photographs, taken mainly at night and set in a sort of vegetal field hospital. Within this pseudo scientific context "suffering" species, trees as well as other plants, are shown receiving "medical treatment."

In order to produce his photographs, Halso has to build and assemble his installations physically before photographing them. The resultant pictures, while sharing certain affinities with the work of Andy Goldsworthy and Nils Udo, are, at the same time, very different in their intent. Halso's approach in the *Restoration* series is less rigidly aesthetic and is imbued with quiet but critical social commentary. Subtle but barbed humor exposes the paradox of treating technologically inflicted environmental damage through the application of yet more technology.

Beautiful but uncanny, Halso's photographs leave the viewer with a feeling of distress which comes from the realization that the photographer's fiction is not that far-fetched, and that if we continue living and consuming as we do, we could find ourselves in a similar situation in the not-too-distant future. ▷ *Ilkka Halso was born 1965 in Orimattila, Finland. He graduated from the University of Art and Design Helsinki in 1992.*

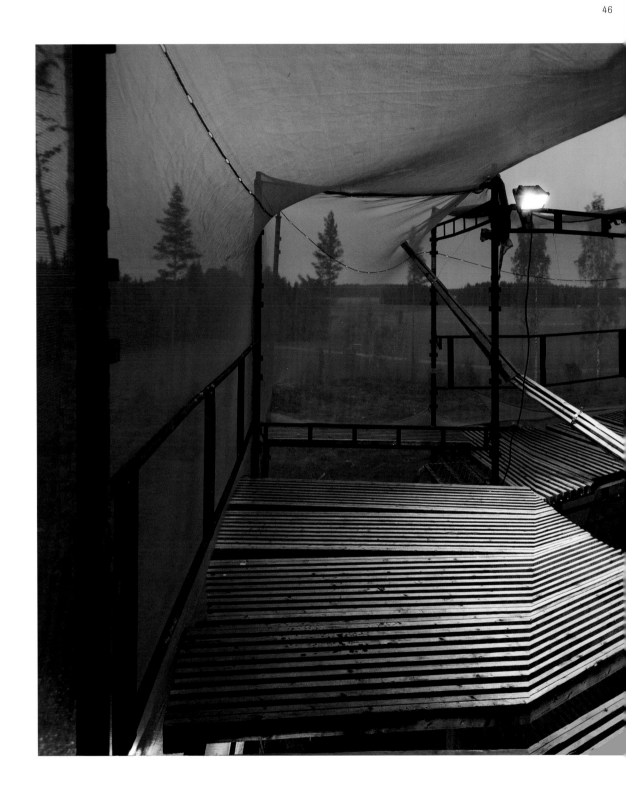

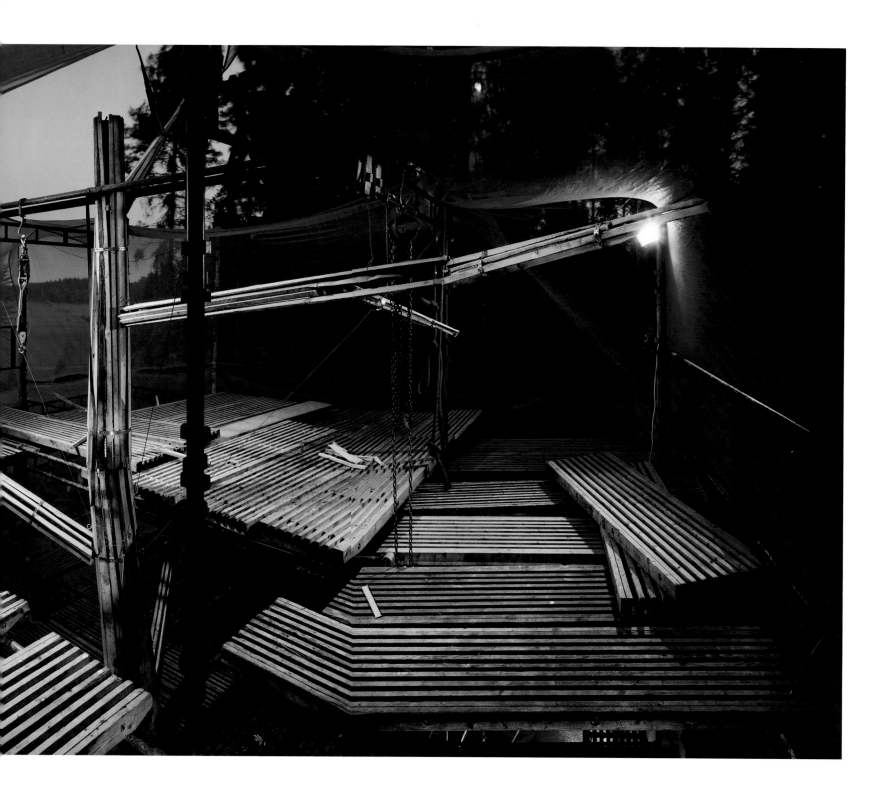

Ilkka Halso

Evolution of Tree, version 2.1 (Inside), 2006, 300 x 140 cm triptych, c-print/aluminum

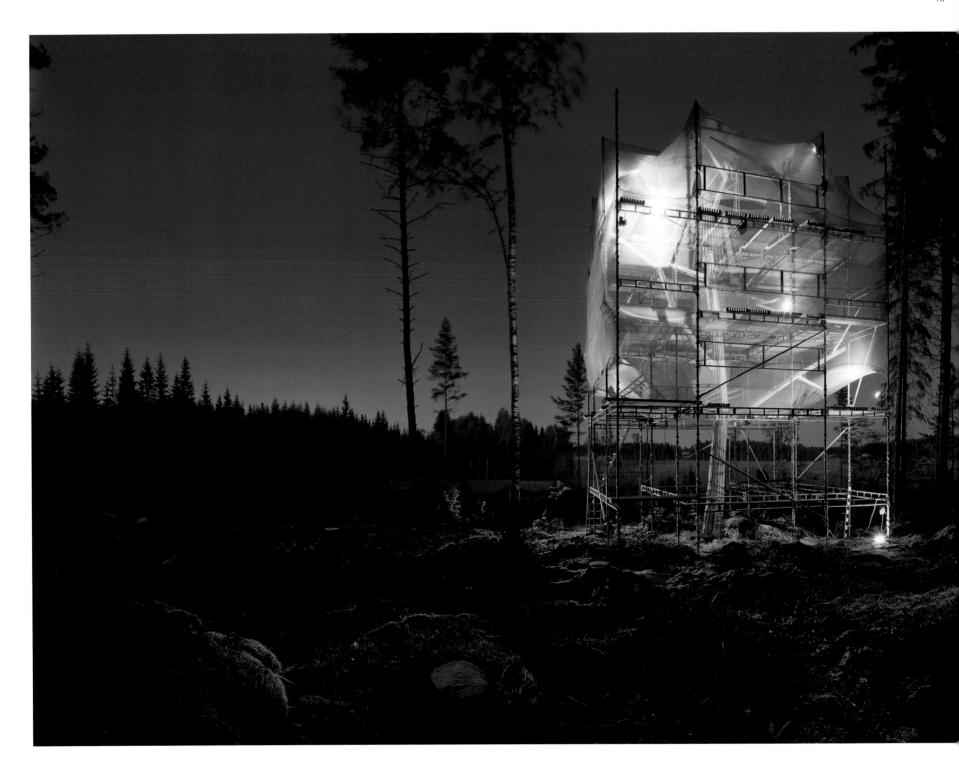

Ilka Halso

Evolution of Tree, version 2.1, 2006, 330 x 165 cm triptych, c-print/aluminum

Marjukka Vainio

Marjukka Vainio's
photographs are very poetic
and highly aesthetical.
They document the silent
world of plants, a world of…

…beauty but also of accelerated cycles of life and death. Vainio shows us the various stages of plant life, from their blossoming to their decomposition. Working within the plant microcosm, Marjukka Vainio creates her own universe composed of leaves, flowers, stems, roots, and seeds, making us see the unnoticed, the hidden, and the invisible.

Compared to Karl Blossfeld's plant studies, Vainio's photographs are not architectonic and staid in appearance. Their colored backgrounds and the iridescent light which seems to emanate from them give them a distinct painterly quality.

Very interested in the alchemy of photography, Marjukka Vainio also sometimes uses the positive method of photographic image making. With this method the photographer does not use a camera in order to fix the image on a negative, but "paints" directly on photographic paper with chemicals and light. The technique was developed by William Henry Fox Talbot in 1839. Vainio has perfected it to include the use of color and various chemical procedures of which she is the inventor. ▷ *Marjukka Vainio was born in 1953 in Renko, Finland. She graduated from the University of Art and Design Helsinki in 1998.*

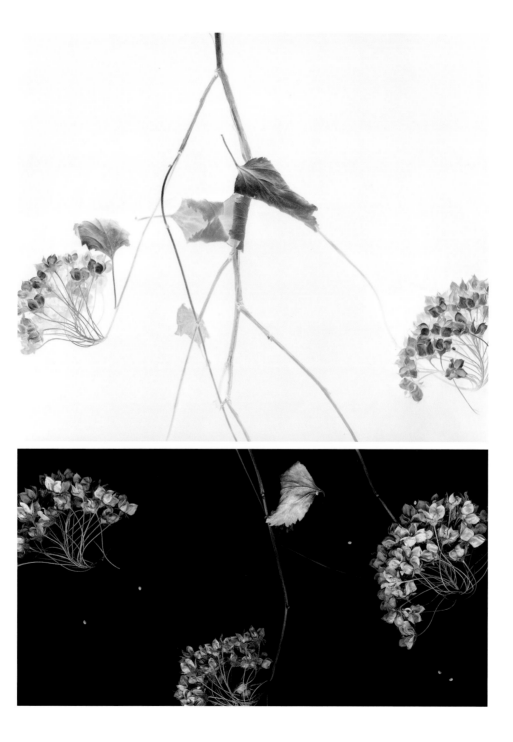

Seeds I, 2006, from the series *Light of the Earth*, 87 x 120 cm, c-print/diasec

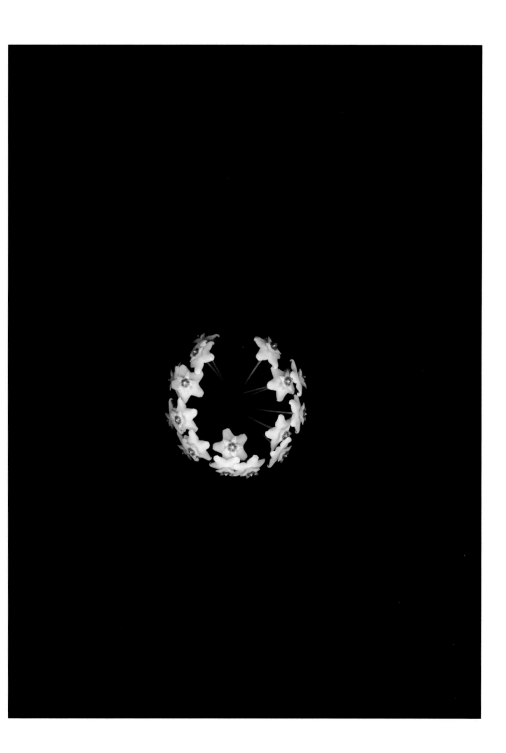

Porcelain Flower I, 2006, from the series Light of the Earth, 165 x 120 cm, c-print/diasec

Petals, 2006, from the series *Light of the Earth*, 120 x 87 cm / 230 x 170 cm, c-print/diasec

String of Hearts I, 2006, from the series *Light of the Earth*, triptych 120 x 87 cm, 120 x 47 cm, 120 x 47 cm, c-print/diasec

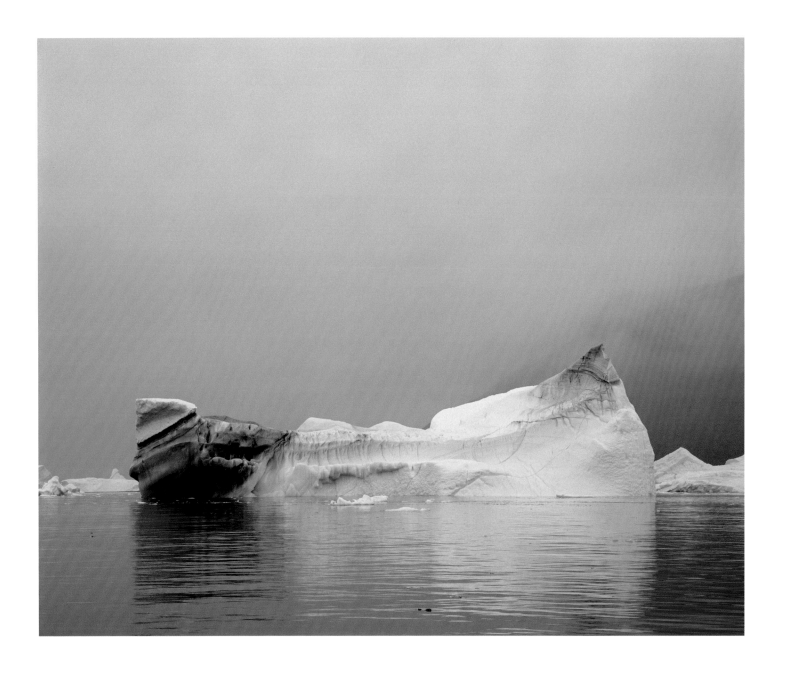

Iceberg III, 2006, 100 x 122 cm, c-print

Inspired by the story of
The Mother of the Sea,
Tiina Itkonen set off, in 1995,
to the place where the story
originated, in Greenland....

…She was so fascinated by this encounter that, for over ten years now, she has traveled regularly to Greenland to spend time with, and photograph, Polar Eskimos and the Polar landscape.

Having visited Greenland over such a long period, Tiina Itkonen has become a witness to the disasters of global warming. She noticed that winters became warmer and sea ice has thinned out. The effects have terrible consequences for hunters but also for the environment since more and more icebergs are calving from glaciers reducing the inland ice.

During her last visits in Greenland, Tiina Itkonen has been particularly concentrating on photographing icebergs. She describes their beauty with fascination: "When I close my eyes I am in Greenland, and the silence is perfect. Bluish light dances across the snow; the icebergs glow turquoise. The silence is broken by a loud crack. An iceberg splits, creating new, smaller icebergs. The ice can be surprisingly varied in color, from crystal clear, through bright white, to dazzling blue. Some of the icebergs look like pyramids, while others resemble whales' tails. The largest can rise like huge apartment blocks a hundred meters over the surrounding sea— and it's easy to forget that about 90 percent of each iceberg lies concealed beneath the waves."

Tiina Itkonen's icebergs are treated as everyday sights rather than exotic monuments.

In her work, the empty beauty of the place, devoid of cars, roads, or signs, has a magnetic resonance. Sometimes it is difficult to identify what we are looking at, there seems to be no depth in this gleaming whiteness. ▷ *Tiina Itkonen was born in 1968 in Helsinki. She graduated from the University of Art and Design Helsinki in 2002.*

Tiina Itkonen

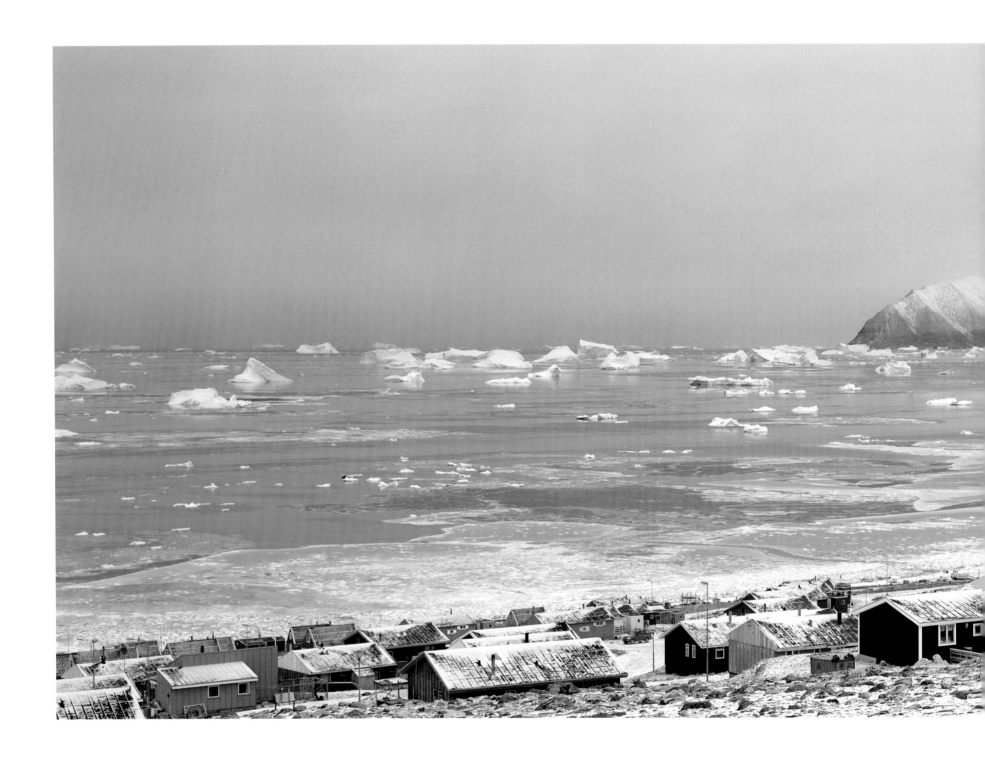

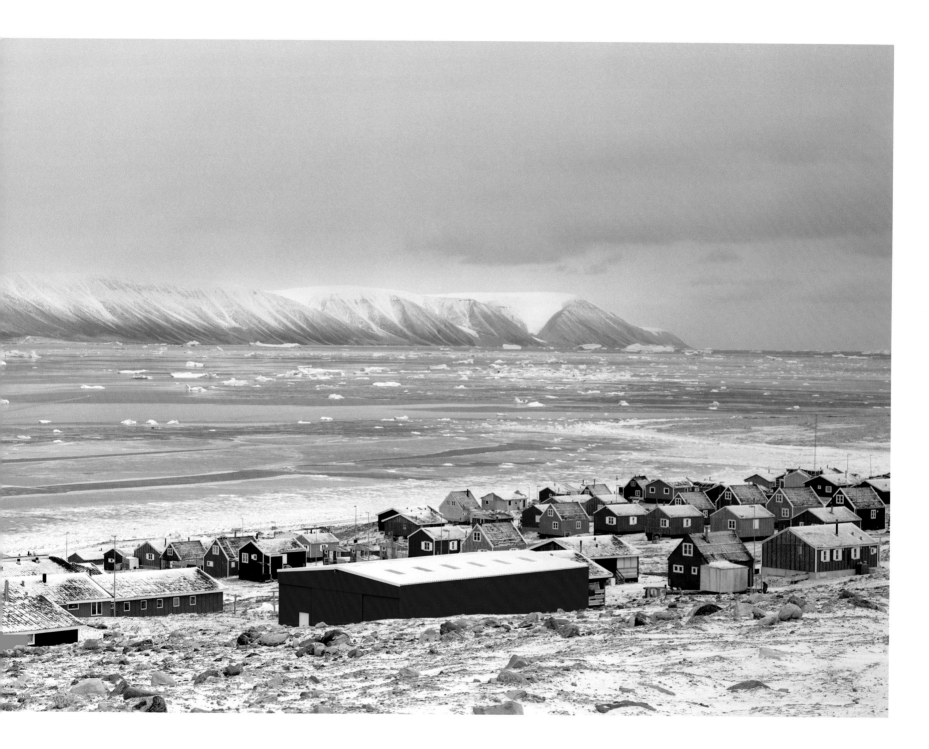

Qaanaaq, 2005, 70 x 200 cm, c-print

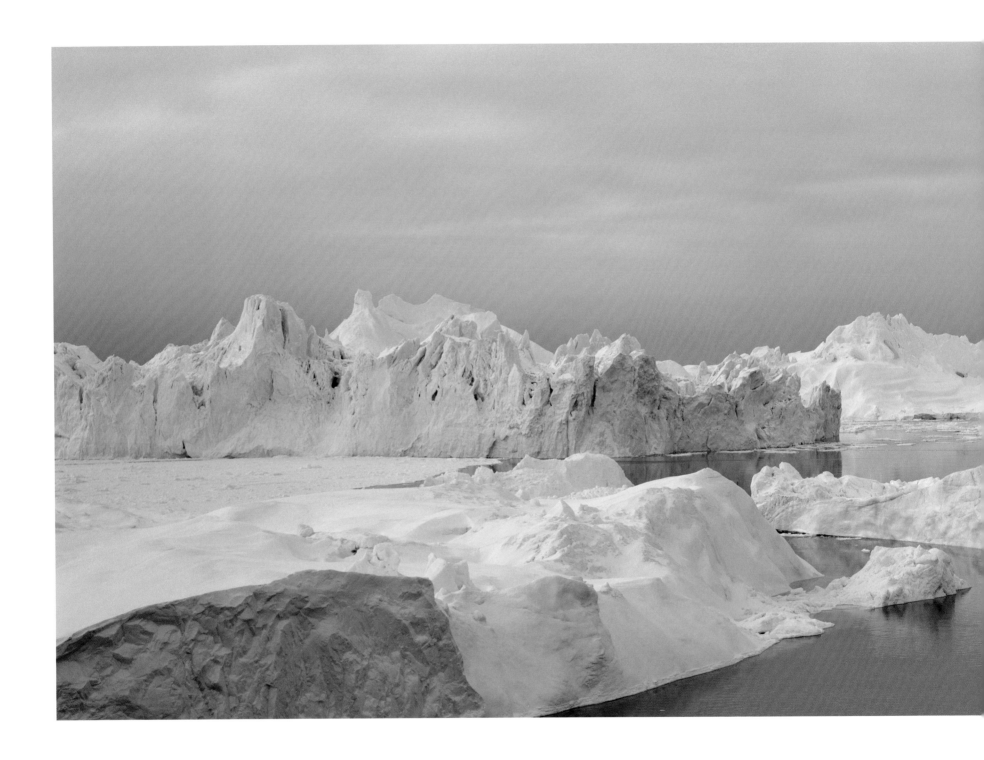

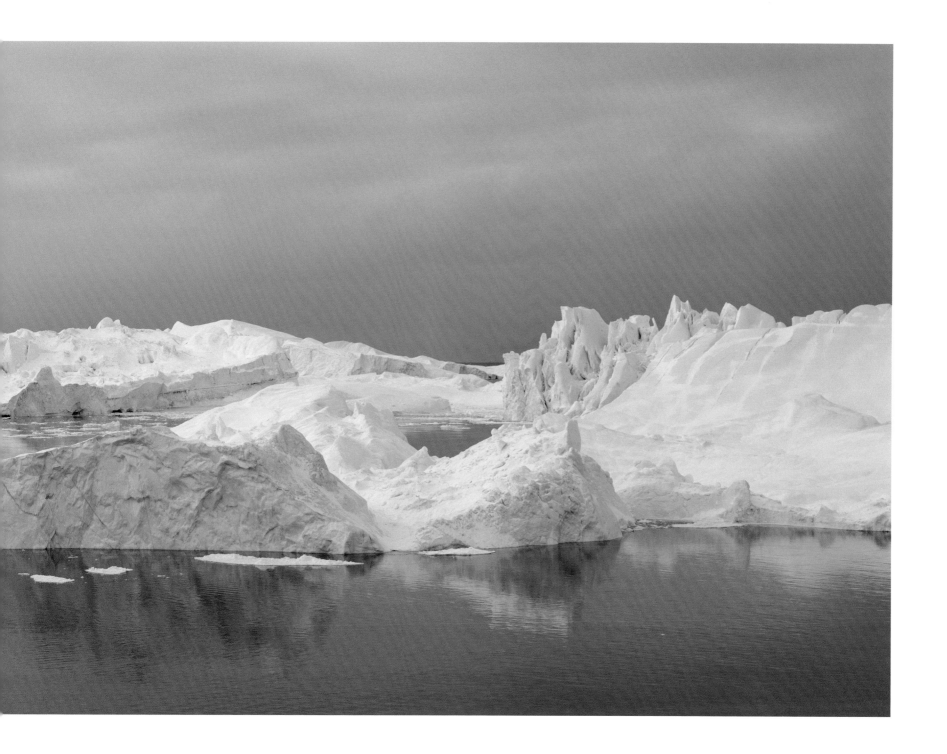

Ice Fjord, 2005, 70 x 200 cm, c-print

Miklos Gaál's photographic landscapes, or urban views, are usually taken from a distant and elevated viewpoint….

…They are characterized by an illogical distribution of blurred and sharp zones within the picture. This mixture of in-focus and out-of-focus areas lends the photographs an unreal quality, like toy worlds or mock decors. To achieve this effect, Gaál manipulates the film plate within the camera. His method being partly random, he never knows exactly how the pictures will appear in the end. Gaál has been using this method of manipulating the image for over five years now, transforming the real into something unknown and strange, something that the viewer not only looks at, but also studies and questions.

Miklos Gaál is part of a generation of artists who have abandoned documentary photography in favor of a more creative approach, but who continue to play on the idea of "factuality" inherent to documentary photography. He comments on his work: "The photographic blur arouse my interest because it shows reality in a new way. The blur prevents the viewer from getting the whole view of the picture at once. I am interested in showing something familiar in a new, unfamiliar, even uncanny way." ▷ *Miklos Gaál was born in 1974 in Espoo, Finland. He graduated from the University of Art and Design Helsinki in 2004.*

Miklos Gaál

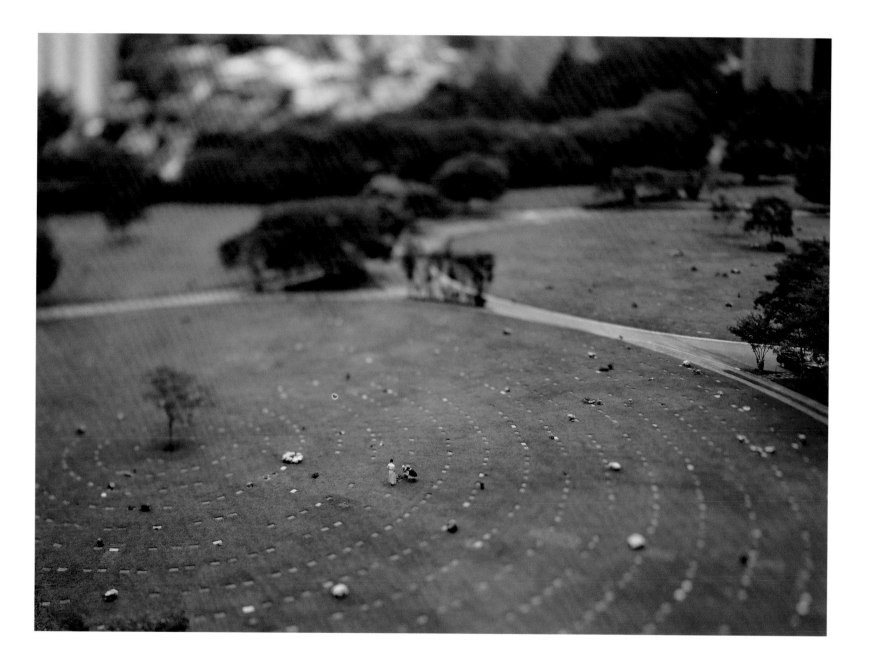

Cemetery visit, 2006, 105 x 144 cm, c-print/aluminum

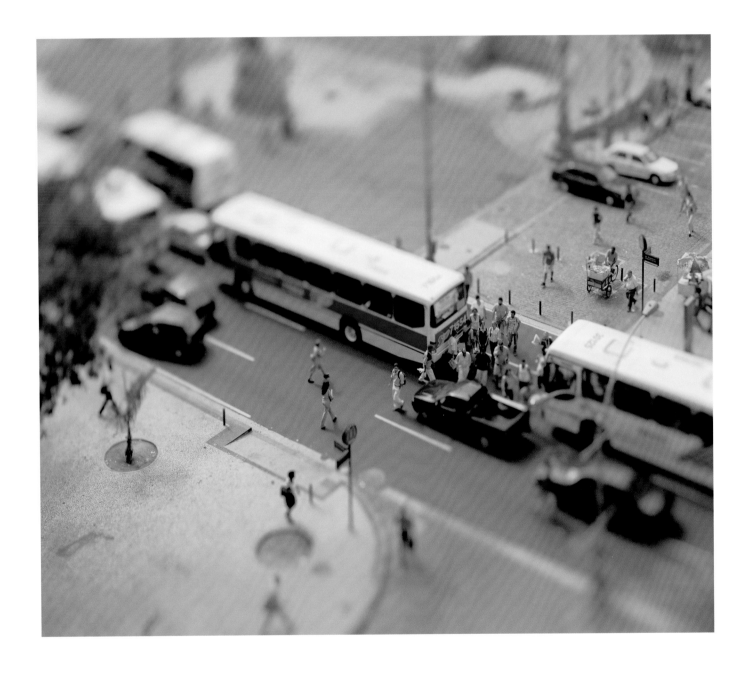

Avenida Presidente António Carlos, 2004, 91 x 109.5 cm, c-print/aluminum

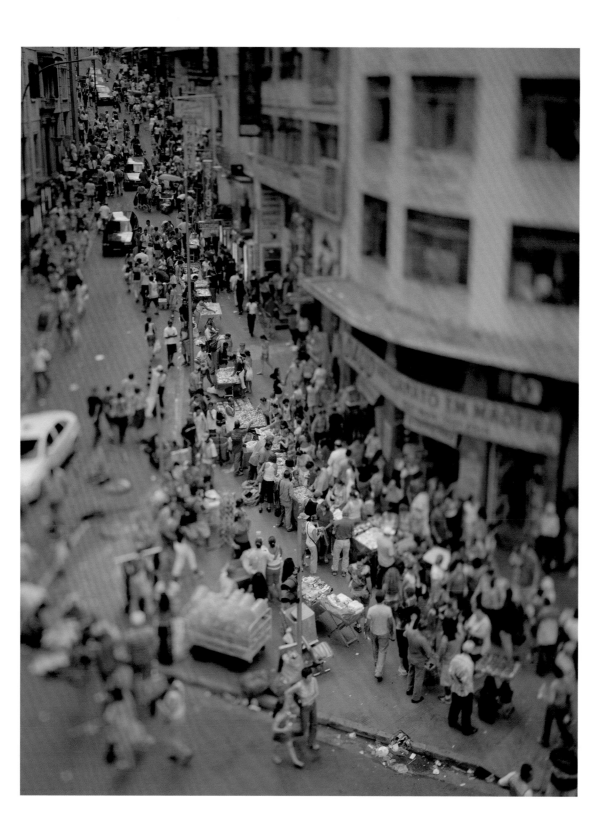

Market street Rua do Mercado, 2006, 109.5 x 138.5 cm, c-print/aluminum

Semana santa 2, 2005, 89 x 112 cm, c-print/diasec

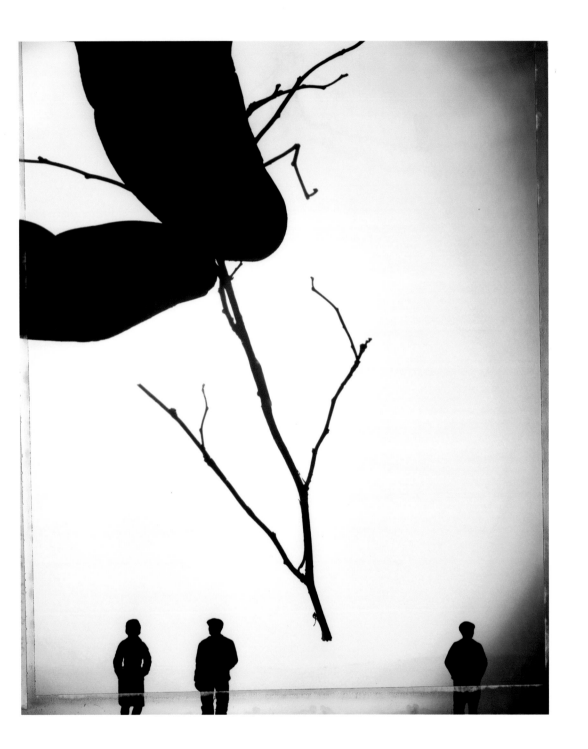

Untitled, 2006, 90 x 110 cm, c-print/diasec

Veli Granö

Using photography and
film, Veli Granö studies
outsiders, meaning people
who have developed a
rationale allowing them…

…to construct an existence in a world which could be said to be parallel to that which we consider to be the normal or real world. In his first series entitled *A Trip To Paradise* and begun in 1985, Granö photographed Finnish folk artists. Questioning the role and the status of art, he portrayed a group of people ignored by the official art world. His work initiated a process of recognition and integration, which culminated in the foundation of the Contemporary Folk Art Museum in Finland.

In his new *Masters* series, from 2006, Veli Granö explores the world of scale model aficionados. The project actually features two different series: color portraits of his subjects and a series of black-and-white photograms (photographic images produced without a camera by placing objects directly onto the surface of black-and-white film and then exposing them to light) of a miniature world. With the black-and-white photograms Granö attempts to visualize the mood and the atmosphere surrounding the scale-model aficionados and their deep concentration on an artificial world in which, omnipotent, they have absolute control. ▷ *Veli Granö was born in 1960 in Kajaani, Finland. He graduated from the Lahti Design Institute in Lahti, Finland in 1986 and has taught at the University of Art and Design Helsinki since 1993.*

Untitled, 2006, 90 x 110 cm, c-print/diasec

Untitled, 2006, each 50 x 60 cm, c-print/diasec

Niko Luoma establishes
the semantics of the
art of photography by using
the conditions of nature....

...In the *Pure Information Praxis* series, Luoma is using a "kaleidoscopic camera" with six mirrors, exploring themes of infinity, chaos, and the unconscious. Inspired by the pure abstraction painters, Luoma is searching for similar states in photography. In his second series *Future me* Luoma explores the semantics of photography using the linguistics of light and time. He is profiting from the accessibility of the camera lens capturing physical phenomena such as spatial light transitions. In essence he bends time and space from one point to another, altering the way we perceive it. ▷ *Niko Luoma was born in 1970 in Helsinki, Finland. He graduated from the University of Art and Design Helsinki in 2003.*

Niko Luoma

Pure Information Praxis, 2005, 150 x 120 cm, c-print/diesec

Crossing the line, 2006, 201 x 167.5 cm, c-print/diasec

All the lines on my table, every angle of creative complex (one day, March). 2006. 160 x 200 cm, c-print/diasec

Niko Luoma

February 13. at 16:52 or March 13. at 16:50, 2006, 160 x 400 cm (diptych, 160 x 200 cm each), c-print/diasec

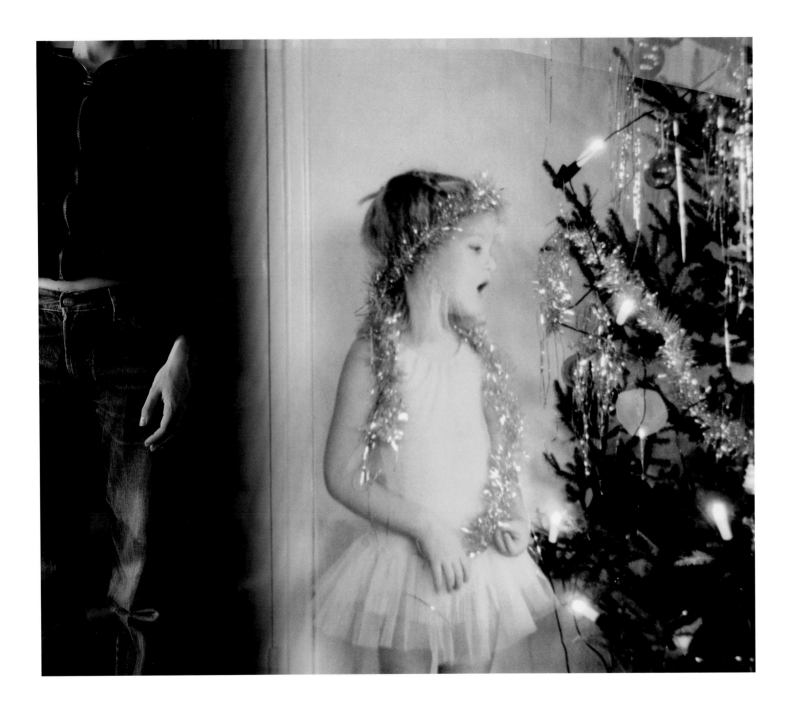

To remember (Christmas), 2005, 35 x 40 cm, c-print/aluminum

In Michael Gondry's film
*The Eternal Sunshine of
the Spotless Mind*, a person
is removed from another
person's memory and all
of the events…

…shared with this person are erased through a pseudo-medical procedure. Something very similar happened to Milja Laurila, but through real traumatism. Milja Laurila lost her father when she was eleven years old. The shock was so profound that it erased all of her memories prior to that day, leaving her with no recollection of her early childhood.

In her series *To Remember*, 2004–2006, Milja Laurila deals with her inability to remember. Unwilling to accept her fate, Milja Laurila uses her artistic creativity to reach back in time and repossess lost events. She does so through the creation of a new personal photo album in which she inserts present experience into past events.

To Remember is composed of old documents and pictures from the family album which the artist combines with new images of present personal experiences.

In order to assemble the different elements of old documents and new pictures, Milja Laurila uses the technique of multiple exposures, rather than that of digital manipulation. She explains that: "For me it is important that the two elements are not separable, that they constitute a whole, also physically. I guess this is my personal attempt to relate myself to some permanent place in time, to belong to and have a history that will not disappear." ▷ *Milja Laurila was born 1982 in Helsinki. She graduated as a Bachelor of Arts from the University of Art and Design Helsinki in 2006 and is now studying for her Master of Arts degree.*

Milja Laurila

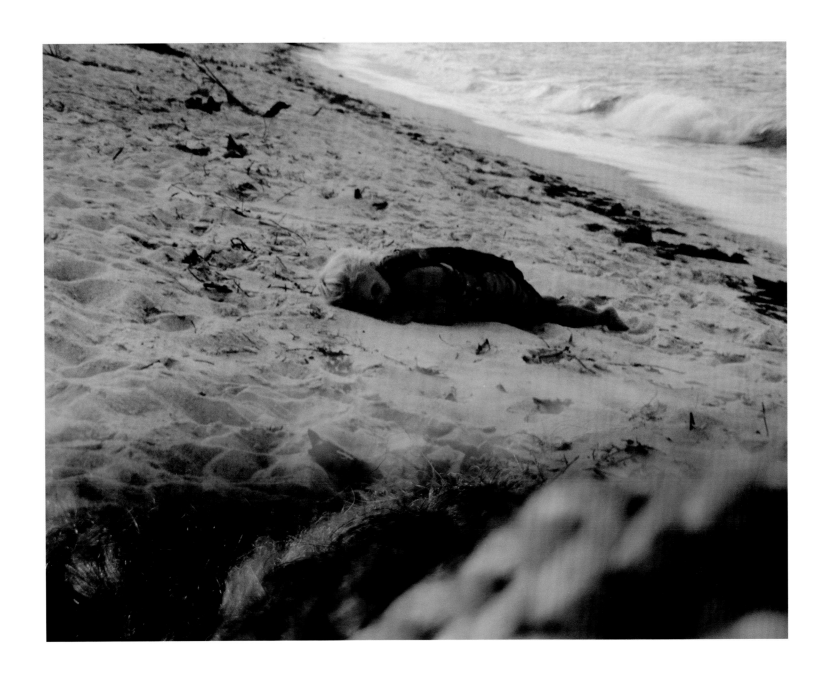

To remember (beach), 2005, 65 x 83 cm, c-print/aluminum

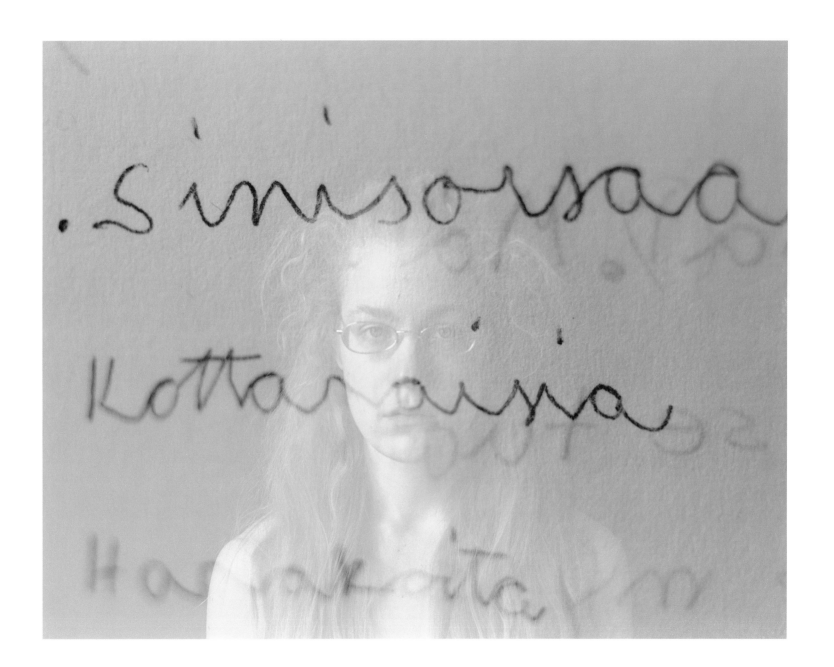

To remember (starlings), 2004, 65 x 83 cm, c-print/aluminum

To remember (mother), 2004, 65 x 83 cm, c-print/aluminum

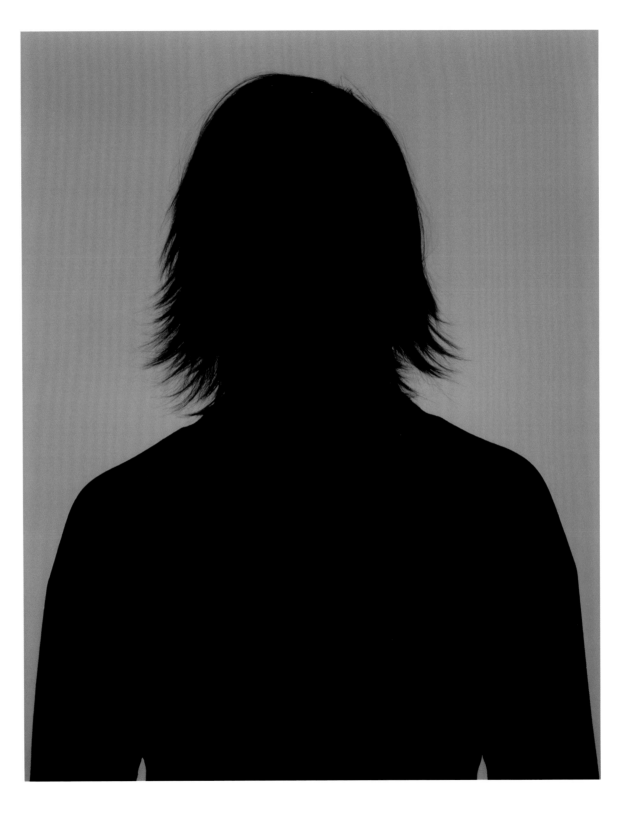

Outer Limits 2, 2004, 125 x 100 cm, c-print/aluminum

Joonas Ahlava

Since its very beginning, the portrait has always been one of photography's most popular subjects. There are manifold applications for the use of the photographic portrait, such as…

…as passport pictures, family portraits, mug shots, official portraits, etc. Usually, a photographic portrait is executed in order to identify someone in time and place and to convey as much information as possible about the subject: sex, age, statue, etc. The photographer's intent is to show the basic appearance of the person and, if the photographer's talent permits it, to give some insight into the sitter's personality.

Not so with Joonas Ahlava's photographs, *Outer Limits*; a series of portraits which only give the outlines of the person he is portraying. The photographs show single-tone silhouettes in front of uniform backgrounds. Undefined, unrecognizable, and imprecise, they are radically different in approach to that of traditional portrait photography.

Joonas Ahlava captures his images on black-and-white film, but taking the picture is only a part of a larger process in which the photographer, working mostly in the darkroom, employs a specific process in order to "create" his works. The results of Ahlava's darkroom experiments are stunning abstract color compositions in which the portrait has been transformed into a simple formal element.

The subjects chosen for his portraits represent the various influences throughout his life. Ahlava then asks the chosen subject "If you had to wear one color the rest of your life, what would it be?" The color chosen combined with Ahlava's own interpretation creates the conceptual palette for his work. ▷ *Joonas Ahlava was born 1975 in Helsinki. He graduated as a Bachelor of Arts from the University of Art and Design Helsinki in 2007 and is now studying for his Masters of Arts degree.*

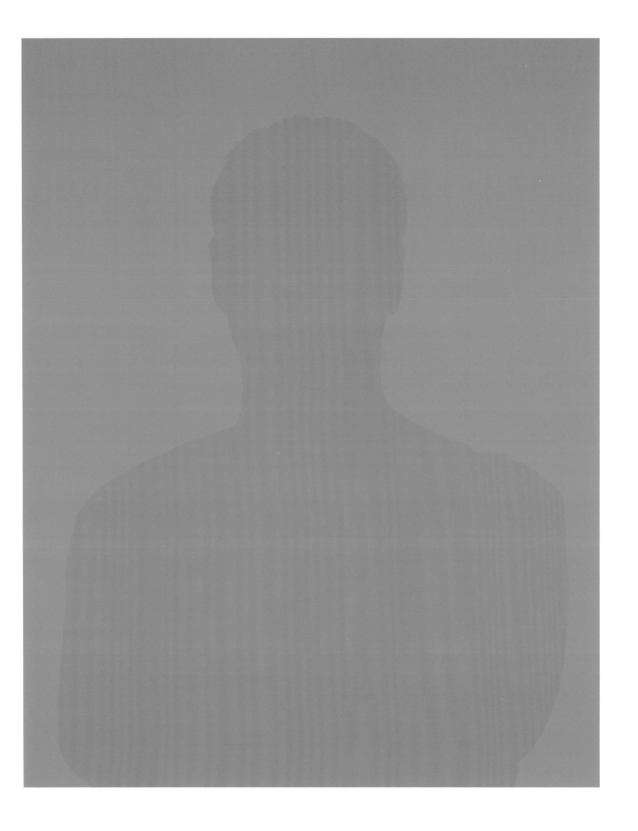

Outer Limits 9, 2006, 188 x 150 cm, c-print/diasec

Jyrki Parantainen's work has always questioned violence in its different forms. In his early series from the nineteen-nineties, Parantainen's main subject was fire, which he featured…

…burning in spectacular mises en scène arranged in old mine shafts or deserted military bunkers. The resulting photographs are fascinating not only because of their beauty and the palpable atmosphere of danger, but also because the viewer can sense the courage and commitment that was needed in confronting the fire in a battle that was at times controlled and at times not. An important aspect of these works is the total implication of Parantainen himself in the realization of the photographs, even if it meant putting his life in danger.

With the end of the fire series in the late nineties, Parantainen became more interested in the symbolic aspect of violence and abandoned his physical, performance-like, involvement in his photographic projects.

In his new series of photographs, Parantainen explores man's physical and psychological vulnerability. Representations of the human body are marked, at their perceived points of vulnerability, by push-pins and attached strings. The strings, pulled tight to a point outside the frame of the image, allude to the presence of an unknown, dominant force. ▷ *Jyrki Parantainen was born in 1962 in Tampere, Finland. He graduated from the University of Art and Design Helsinki in 1992 where he is now teaching.*

Jyrki Parantainen

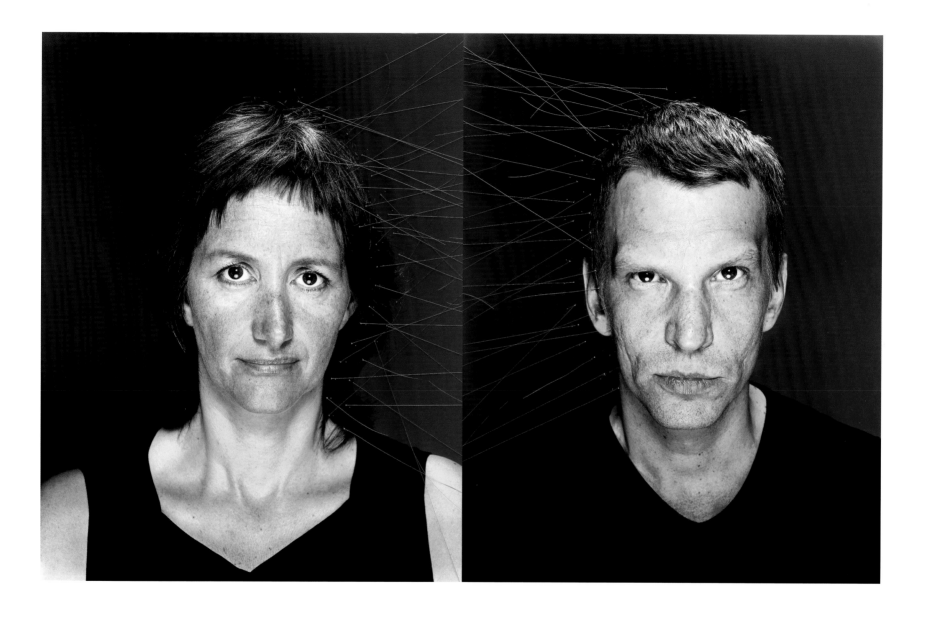

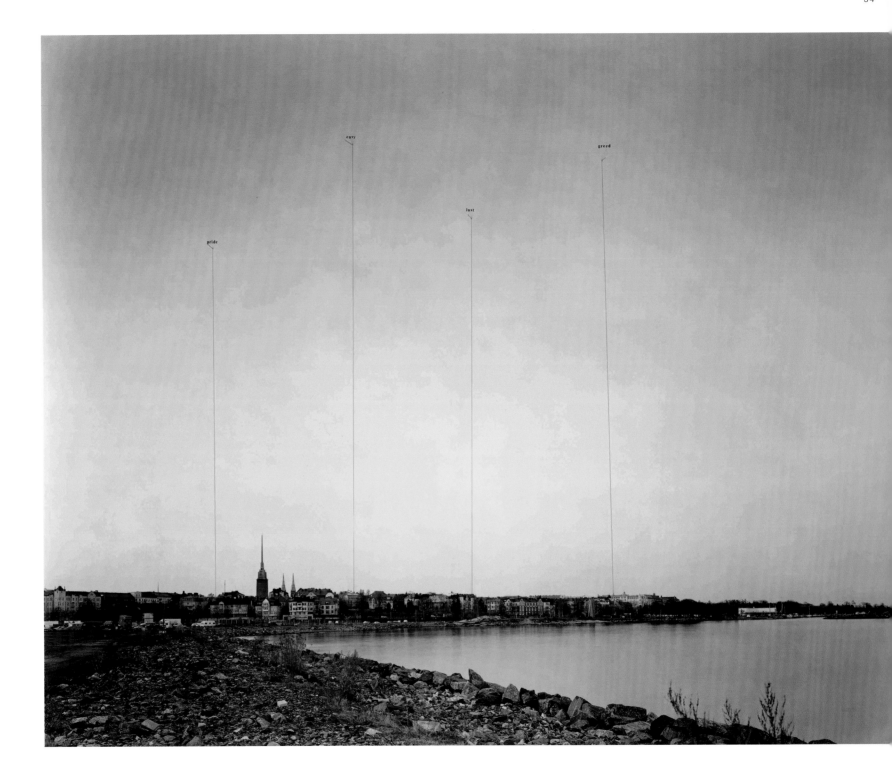

Horizon, 2006, diptych 120 x 300 cm, c-prints/aluminum

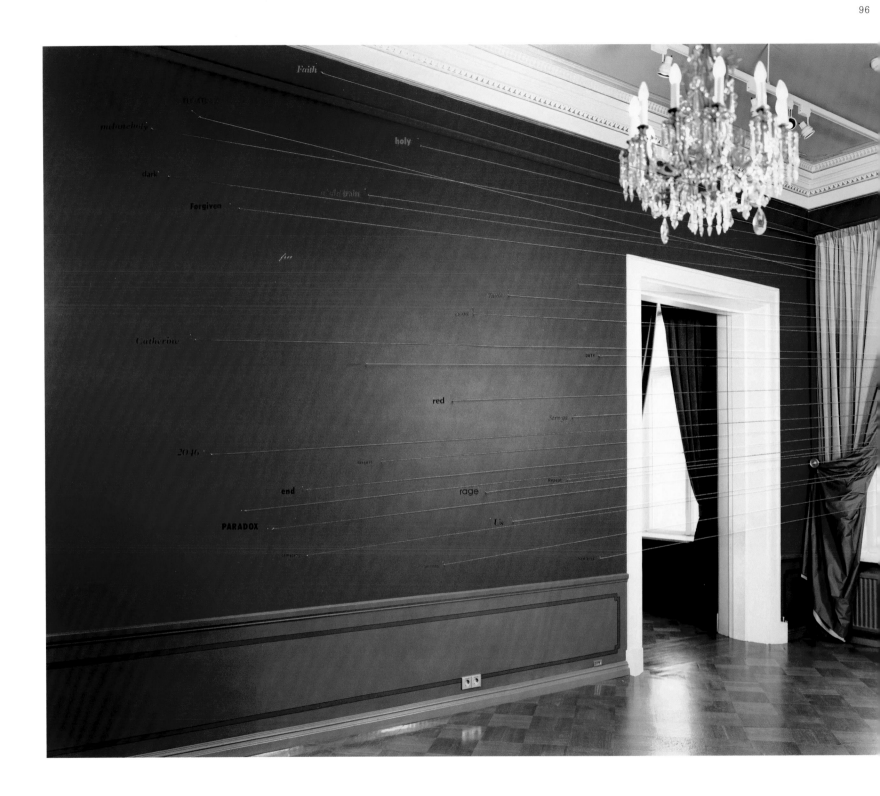

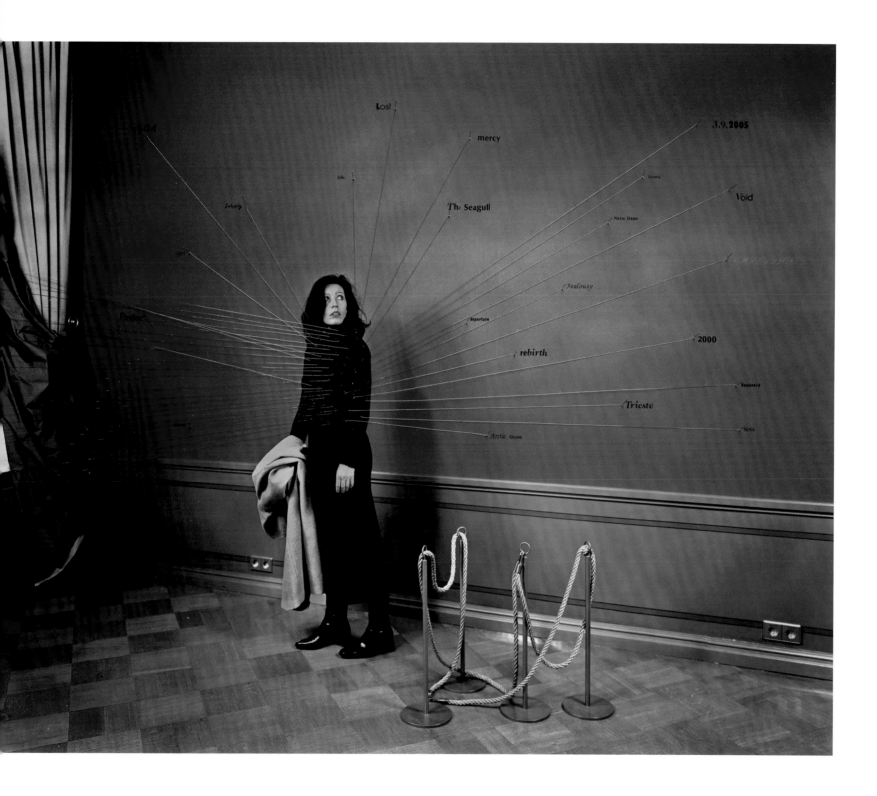

Jyrki Parantainen

Personal Museum, 2006, diptych 100 x 260 cm, c-prints/aluminum

Aino Kannisto

Aino Kannisto's photographs are constructed fictions in which she, the artist, plays the central role....

…When, in the mid-nineties, she began documenting her personal life, Kannisto soon found the resultant self-portraits to be limiting and instead turned her work into a form of emotional narrative. Inspired by literature, music, film, and other art forms, Kannisto creates pictures that are like film stills or visual cutouts of short stories. In order to produce her work, Kannisto proceeds as if making a movie; first preparing her script, either by drawing or writing, then creating her own decors or using already existing interiors which she slightly modifies if necessary. These little mises en scène become the settings for Kannisto's stories of human emotions such as fear, despair, longing, emptiness, and boredom. The fact that she is always the figure "portrayed" in the pictures reinforces the idea of an ongoing narrative, creates a sense of familiarity, and allows the viewer more immediate and intimate access to the work.

Even if the settings are meticulously prepared, Kannisto leaves her scripts open-ended. In spite of her being the writer, photographer, and the actor, literally behind and in front of the camera, there is always a certain element of surprise in each of her works. To Kannisto, this uncontrolled aspect of the process of creation is very important. It is the reason why she uses herself as a model, deliberately surrendering the objectivity of directorial control that she would have by employing professional actors. Through this subjective and highly intuitive approach Kannisto is able to depict emotion in ways that reflect the uncontrollable nature of feelings as they are manifested in reality. ▷ *Aino Kannisto was born in 1973 in Helsinki, Finland. She graduated from the University of Art and Design Helsinki in 2001.*

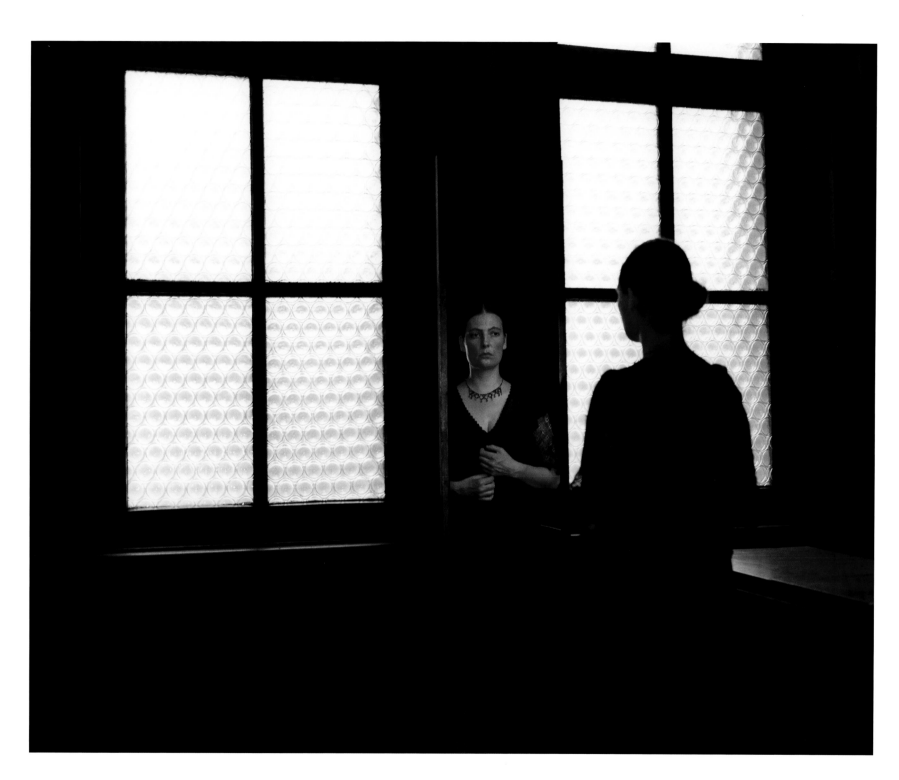

Aino Kannisto

Untitled (Black Mirror), 2005, 90 x 110 cm, c-print/diasec

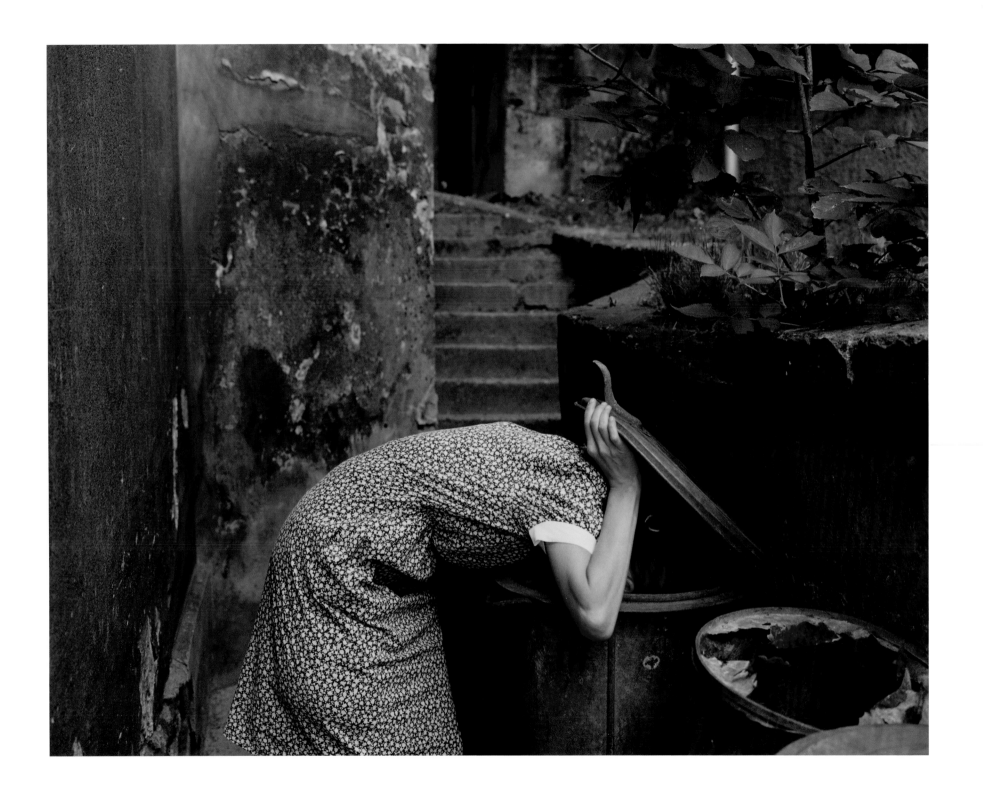

Untitled (Trashbin), 1999, 90 x 115 cm, c-print/diasec

Aino Kannisto

Untitled (White Mirror), 2006, 90 x 111 cm, c-print/diasec

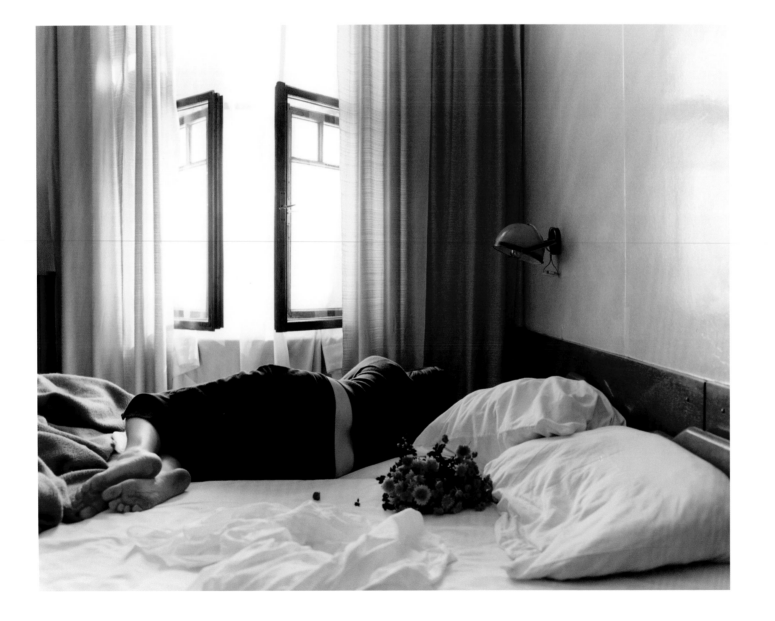

Untitled (Flowers on Bed), 2006, 90 x 110 cm, c-print/diasec

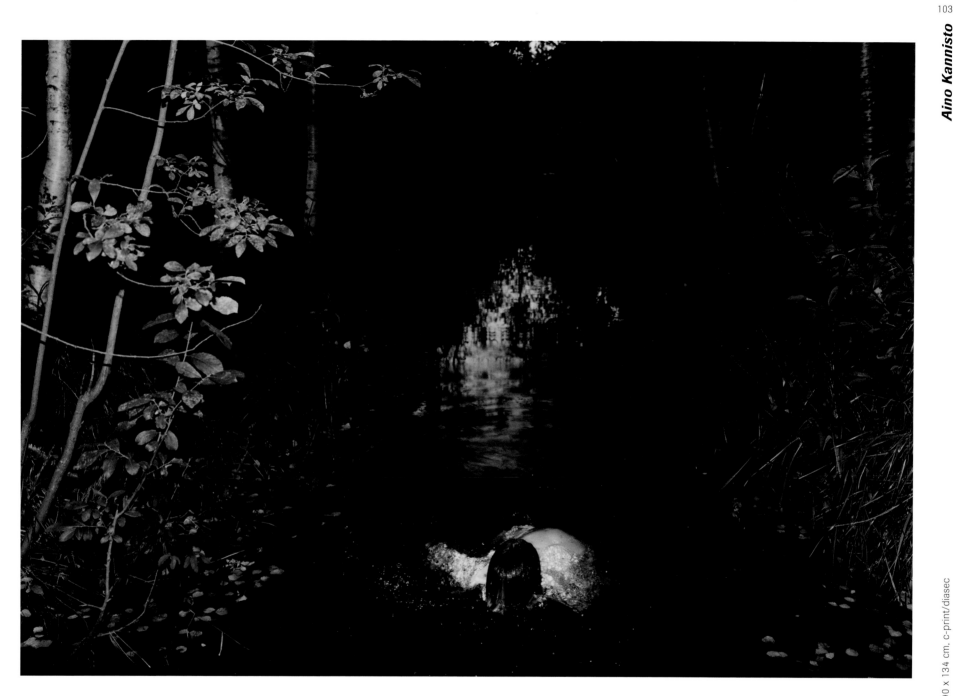

Untitled (Black Water), 1998, 90 x 134 cm, c-print/diasec

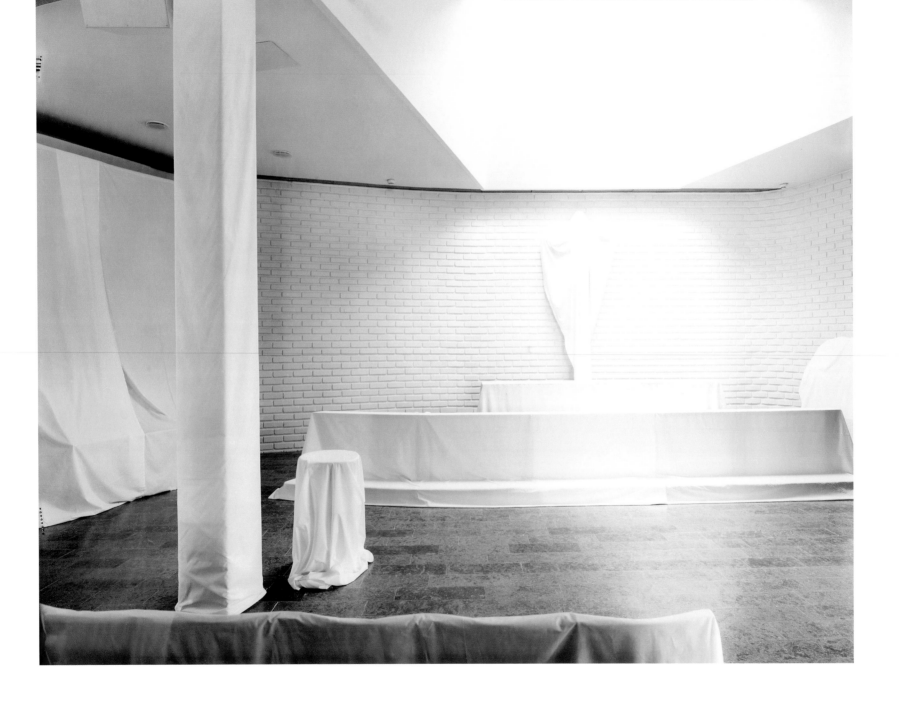

Ceremony # 1, 2005, 125 x 150 cm, chromogenic print/aluminum

Ari Kakkinen

Ari Kakkinen's photographs feature places, spaces, objects, and human beings covered by white cloth....

…Only a shape of what was there before, the rooms, objects, or even human beings, remains. Identity is lost and form replaces appearance. In Ari Kakkinen's photographs, details and colors are veiled. Light and whiteness prevail. Here however whiteness is not reductive but rather, pregnant with signification.

Ari Kakkinen describes his approach as follows: "In these white images there is a struggle between narrative and a pure uncommunicative visuality. I am looking for the point at which the abstract image becomes a story, takes on communicative meaning. As no blank canvas can be painted, no pure abstraction can be achieved. But there is also the turning of the common into the uncanny resemblance of nothing."

The veiled worlds in Ari Kakkinen's photographs transmit vague, ghostly, even deadly feelings. The viewer only gets an approximate idea of the space and the different objects contained within it. One could find many references to the work, but the one particularly important to the artist is Jacques Derida's quote on erasure, "The gesture of *sous rature* (putting under erasure) implies 'both this and that' as well as 'neither this nor that,' undoing the opposition and the hierarchy between the legible and the erased." Jacques Derrida, *Of Grammatology* (Baltimore, 1974), p. 320, n. 54. ▷ *Ari Kakkinen was born in 1966 in Iisalmi, Finland. He graduated as a Master of Arts from the University of Art and Design Helsinki in 2005 and is currently studying for his doctoral thesis at the same university.*

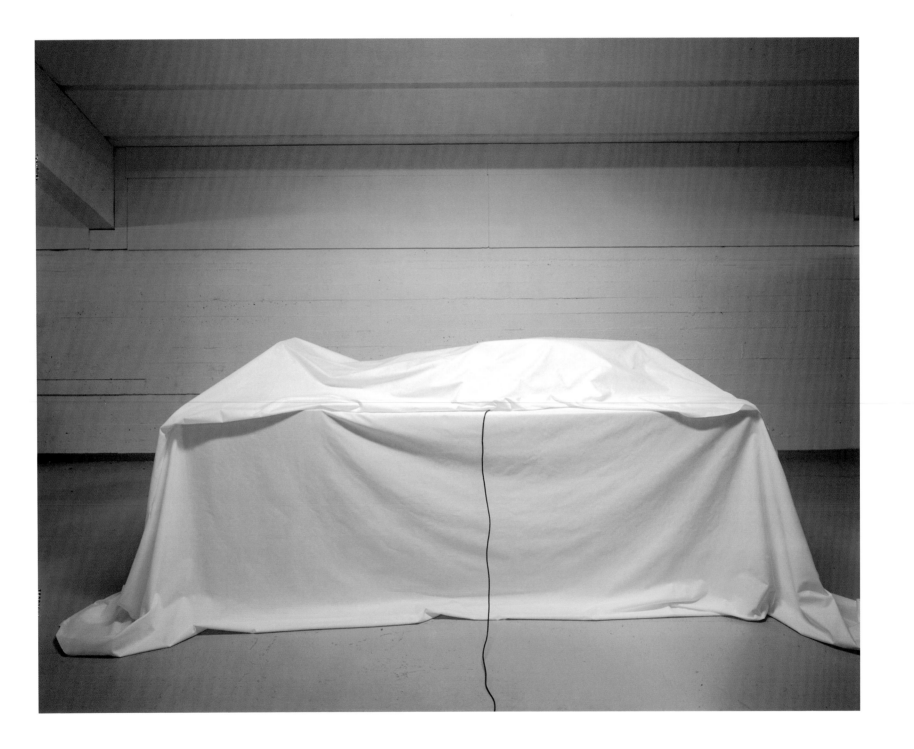

La mort de l'auteur (The Death of the Author), 2004, 125 x 150 cm, chromogenic print/aluminum

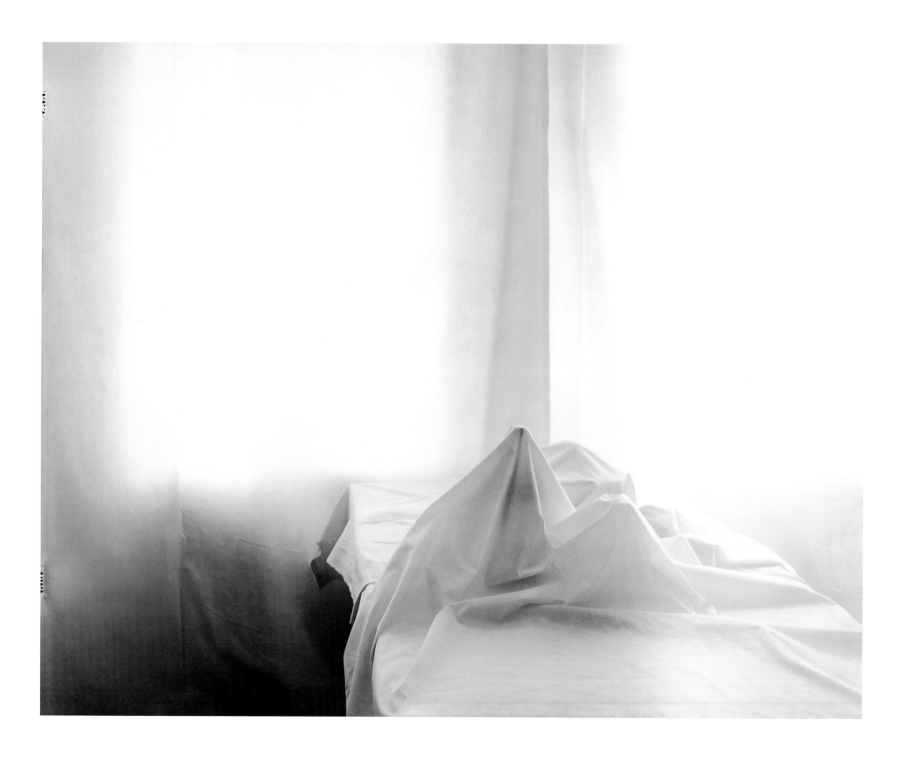

Our Daily Bread, 2004, 125 x 150 cm, chromogenic print/aluminum

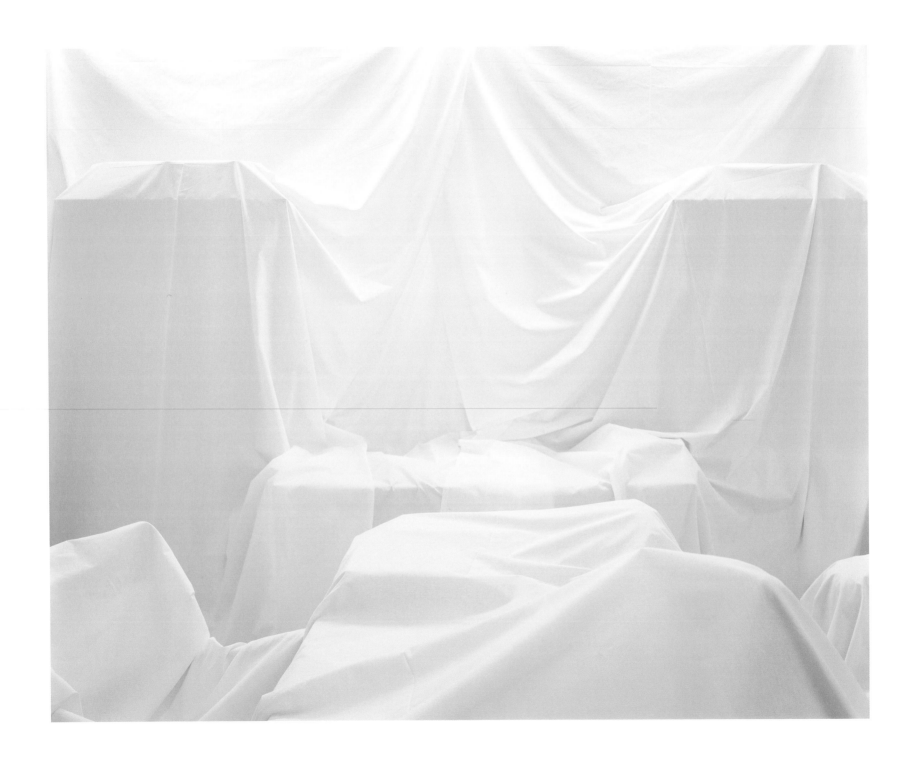

No Echo, 2004, 125 x 150 cm, chromogenic print/aluminum

Ola Kolehmainen's artistic approach has been very much influenced by Constructivist and Minimalist painting....

...Working mainly with the theme of architecture, Ola Kolehmainen photographs buildings and façades from locations all over the world. In Kolehmainen's photographs, however, the documentary aspect is not a priority. It is not the buildings as architectural works of art that he is interested in, but rather, specific elements of the architecture which he abstracts from the architectural form and employs as source material for his photographs. Kolehmainen photographs selected details of the structures, from specific points of view. By thus obliterating the forms' initial functions and scale, he transforms the original subject into a two-dimensional pattern. Kolehmainen's works present repeated patterns of simple geometrical forms that, through the process of photography, become planar surfaces. As he explains, "The original forms of my subjects often contain many repeated elements, a single form or material, often the same, in large quantities. When three-dimensional forms of this kind are photographed they tend to become surfaces, planes."

Large in size, the photographs lend the works an imposing physical presence in relation to both the surrounding environment and the viewer. ▷ *Ola Kolehmainen was born in 1964 in Helsinki, Finland. He graduated from the University of Art and Design Helsinki in 1999.*

Ola Kolehmainen

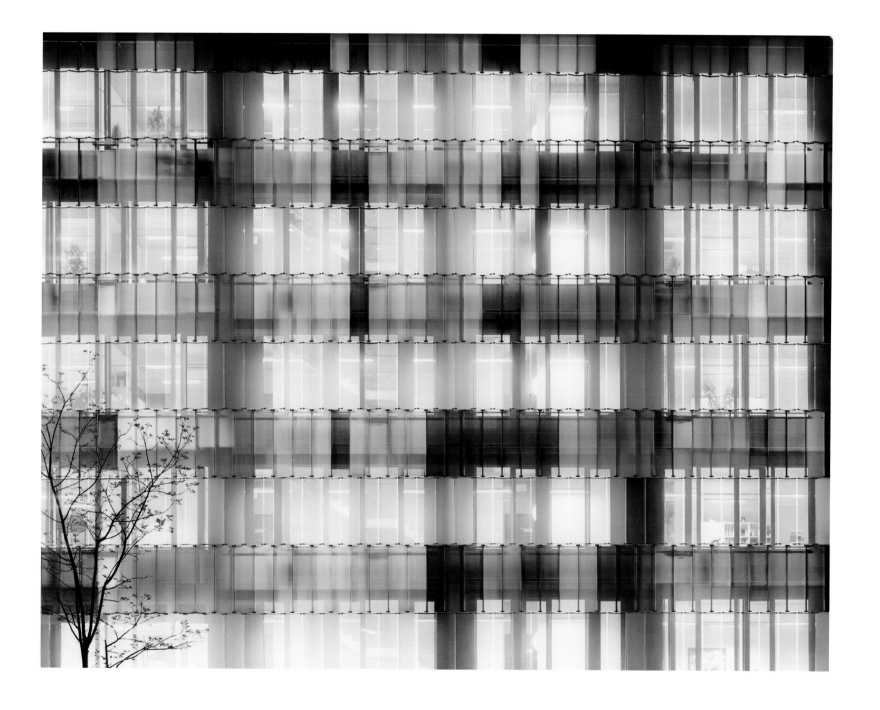

Untitled (No. 6), 2005, 180 x 232 cm, c-print/diasec

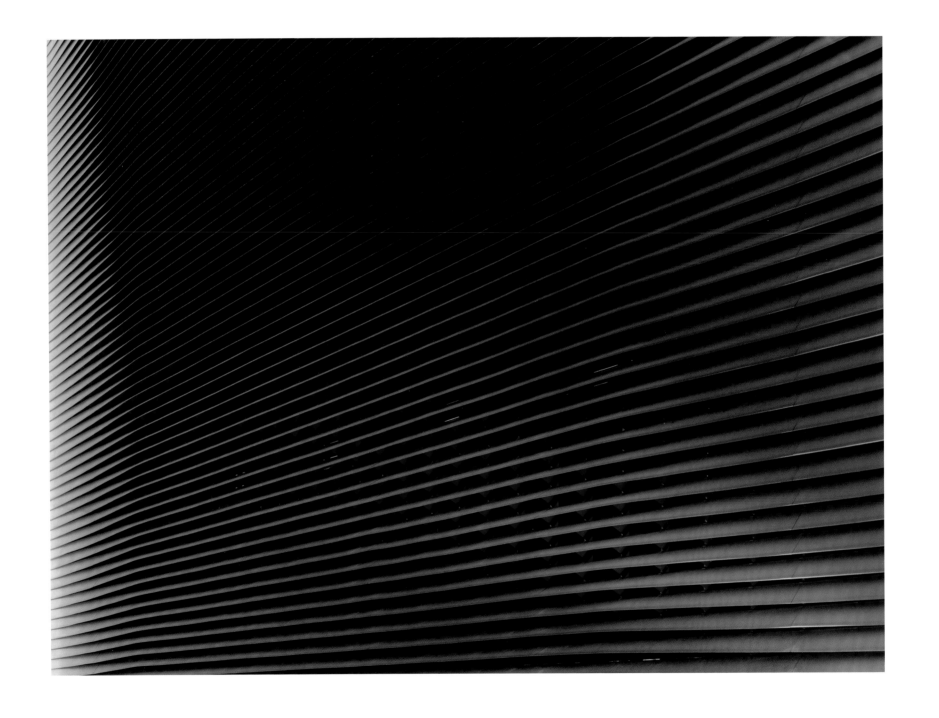

Untitled (No. 24), 2005, 180 x 267 cm, c-print/diasec

In its Own, 2006, 230 x 180 cm, c-print/diasec

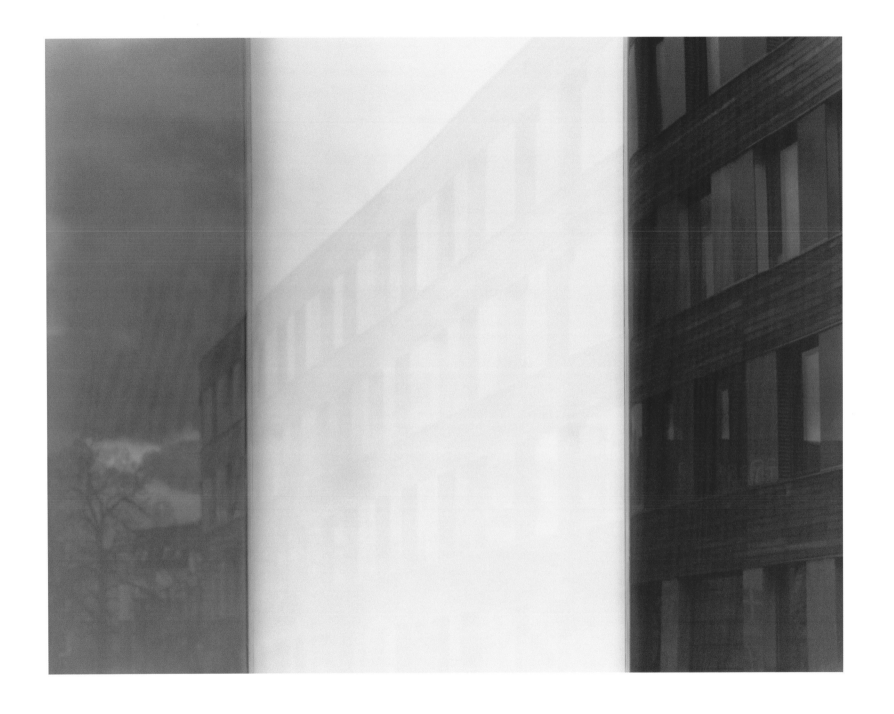

Mirrors and Windows (Orange, White, Red), 2006, 180 x 235 cm, c-print/diasec

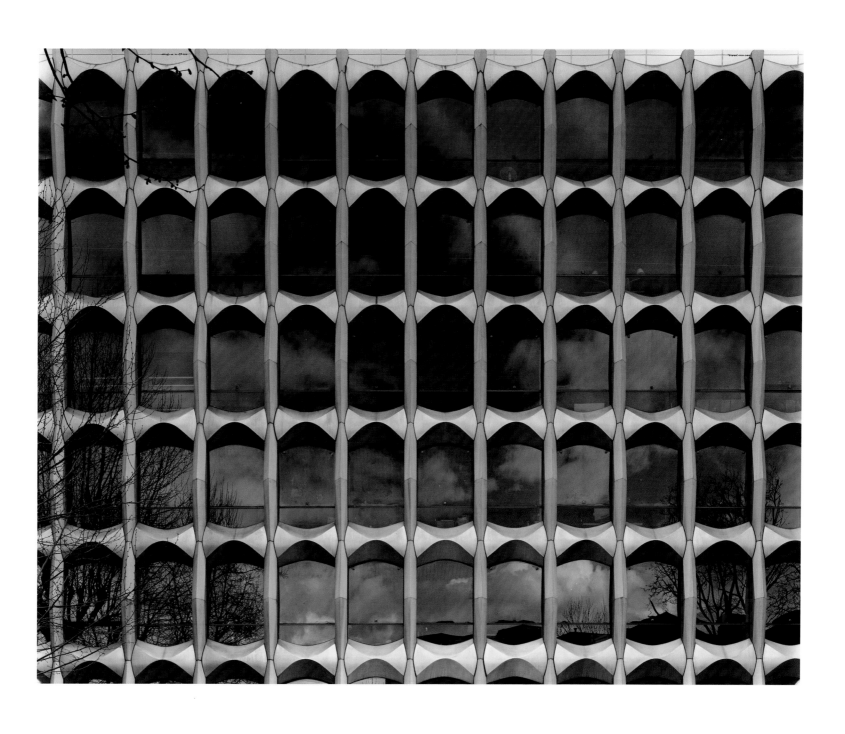

Ola Kolehmainen

Unpredicted Composition with Clouds, 2006, 180 x 232 cm, c-print/diasec

Glacier, 2006, 120 x 150 cm, c-print/diasec

Landscape is a genre which has a long artistic tradition in the Nordic countries. The word landscape derives from the Dutch *landschap*, meaning a sheaf, a patch of cultivated land....

…For Mikko Sinervo landscape is an emotional space. In his new photographic series, he uses images of various landscapes which he combines and assembles into a single image. By blending these different images together, he builds up a personal representation of the surrounding space. Sinervo's landscape photographs consist of layers of time and space, much like layers of sediments in a lake or seabed. The results of his manipulated photographs are beautiful abstract views in which the landscape is recognizable as such but not identifiable as a specific place. Presented at times in diptyches or triptychs, Mikko Sinervo suggests that his work be read as if one were traveling through a landscape.

Mikko Sinervo explains his approach as follows: "For me, seeing the landscape is to feel it. Landscape can be very personal and abstract, something more conceptual. It is the sensitive and beautiful moments in everyday life. It is the path from white … to the color of shadow."

▷ *Mikko Sinervo was born 1981 in Helsinki. He graduated as a Bachelor of Arts from the University of Art and Design Helsinki in 2005 and is now studying for his Master of Arts degree.*

Mikko Sinervo

Untitled Series I, 2006, quadtych 88 x 440 cm, c-print/diasec

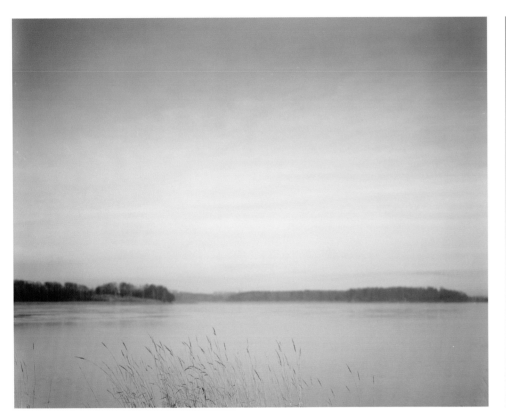

Untitled series II, 2006, triptych 88 x 330 cm, c-print/diasec

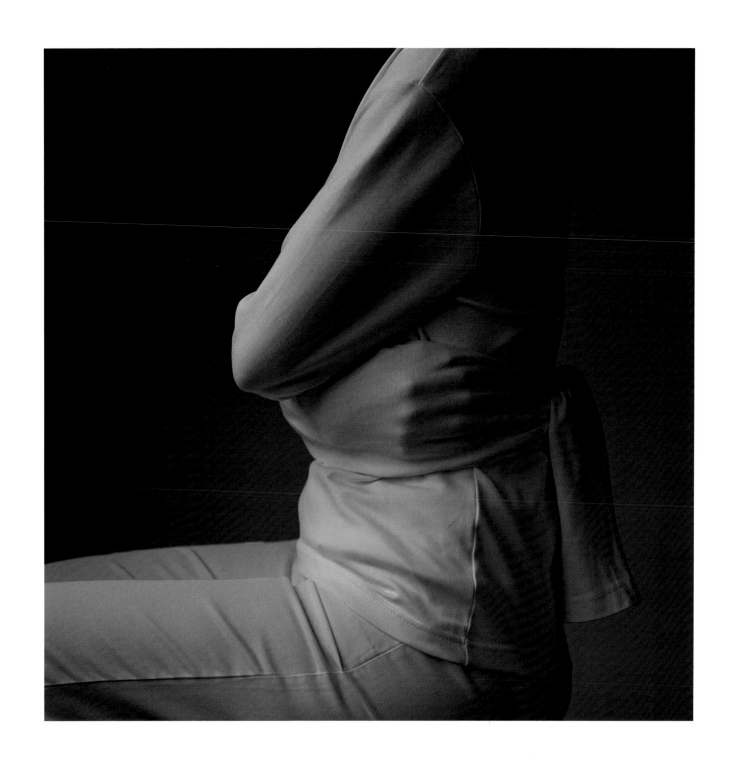

Yes, 2005, 120 x 120 cm, c-print/diasec

Pernilla Zetterman

In her artistic approach, Pernilla Zetterman often combines the still image of photography with the moving video image….

…In general terms one could say that her work, based on personal experience, is centered on her private life and her own subjective feelings. Her photographs, representing simple, everyday objects or people, in a straightforward and objective manner, have a cool and distant feel to them.

In her still ongoing project entitled *When*, which she started in 2004, Pernilla Zetterman focuses on issues concerning identity, especially the heritage of behavioral patterns which are transmitted from one generation to the next. Using her personal surroundings and private life as a case study, she observes the behavior of her grandmother and her mother, as well as her own behavior, in order to see what kind of behavioral or psychological patterns are transmitted from one person to the other.

Part of project is the series *Behave* from 2005, which illustrates details and everyday items from her grandmother's, her mother's, and her own life. The question Pernilla Zetterman raises, in this project, is one of self-definition of the human being, and of his or her actual freedom in relation to others. ▷ *Pernilla Zettermann was born 1970 in Stockholm. She graduated from the University College of Arts, Crafts and Design, Stockholm in 2002. She studied for two semesters at the University of Art and Design Helsinki.*

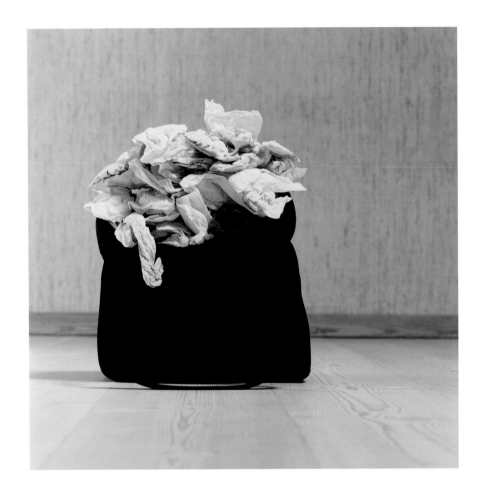

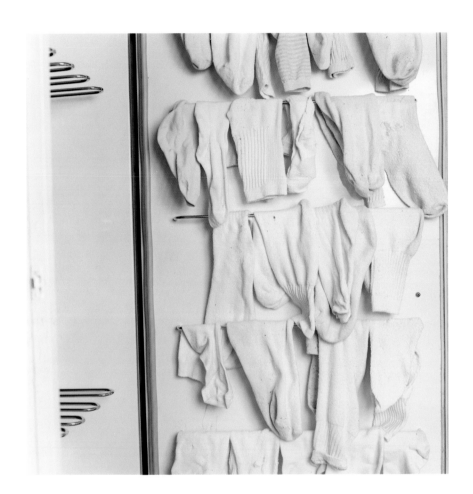

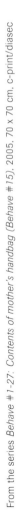

From the series *Behave* #1-27. *Contents of mother's handbag (Behave #15)*, 2005, 70 x 70 cm, c-print/diasec

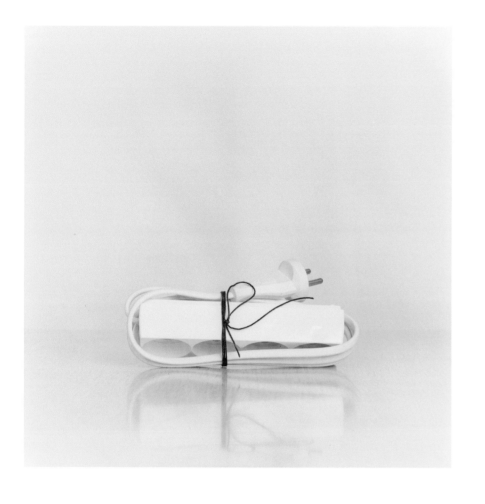

Pernilla Zetterman

From the series *Behave* #1-27: *Grandmother's cord (Behave #7)*, 2005, 50 x 50 cm, c-print/diasec
From the series *Behave* #1-27: *Grandmother's washed plastic bag (Behave #6)*, 2005, 60 x 57 cm, c-print/diasec

Everything is fine # 1 - 3, 2005, 3 x 80 x 80 cm, c-print/diasec

Riitta Päiväläinen's work could be defined as the emotional archaeology of the ordinary. Using old clothes…

…that she finds in second-hand shops and flea markets, Päiväläinen creates installations in landscapes which she then photographs.

For Päiväläinen, the clothes are vestiges of human beings, retaining traces of the history of the person who wore them, long after having been discarded. The garments represent both the presence and the absence of their former owners. Like artifacts found in an Egyptian tomb, the clothes, with their faded colors and torn fabric, bear the signs of time and usage.

The landscape is thus not a topographical and objective phenomenon for Päiväläinen. Rather it is subjective and highly evocative, representative of the cycle of life. Päiväläinen uses the properties of the landscape as a stage for displaying the clothes. Soaked in water and placed outside in the cold, the garments freeze solid, filling out as if someone were wearing them. This process gives them a sculptural quality and opens up manifold metaphorical and narrative possibilities. The clothes become part of nature which interacts with and animates them. Päiväläinen's photographs turn these three-dimensional, real-time encounters back into an object and a surface. ▷ *Riitta Päiväläinen was born in 1969 in Maaninka, Finland. She graduated from the University of Art and Design Helsinki in 2002.*

Riitta Päiväläinen

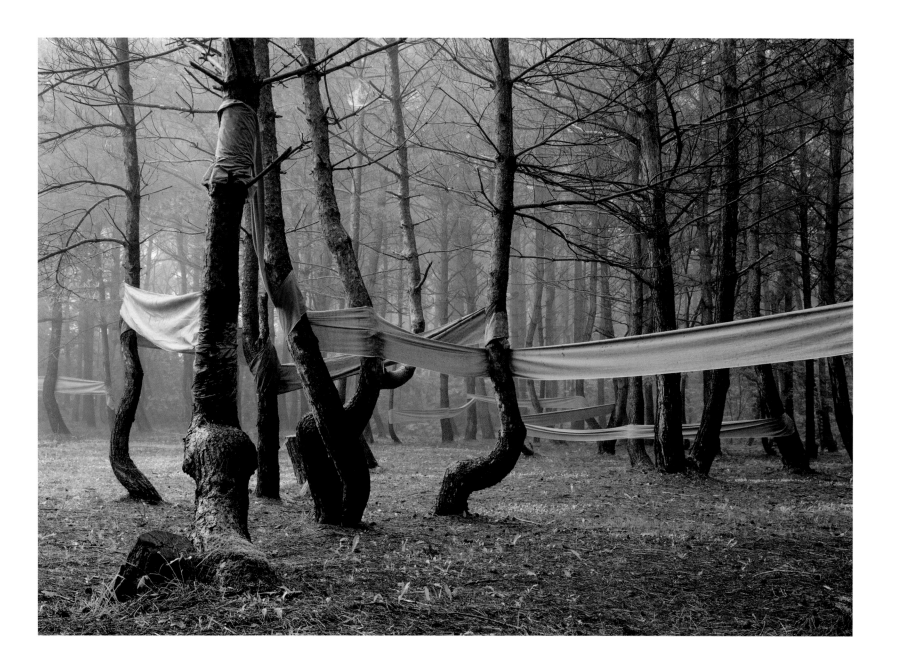

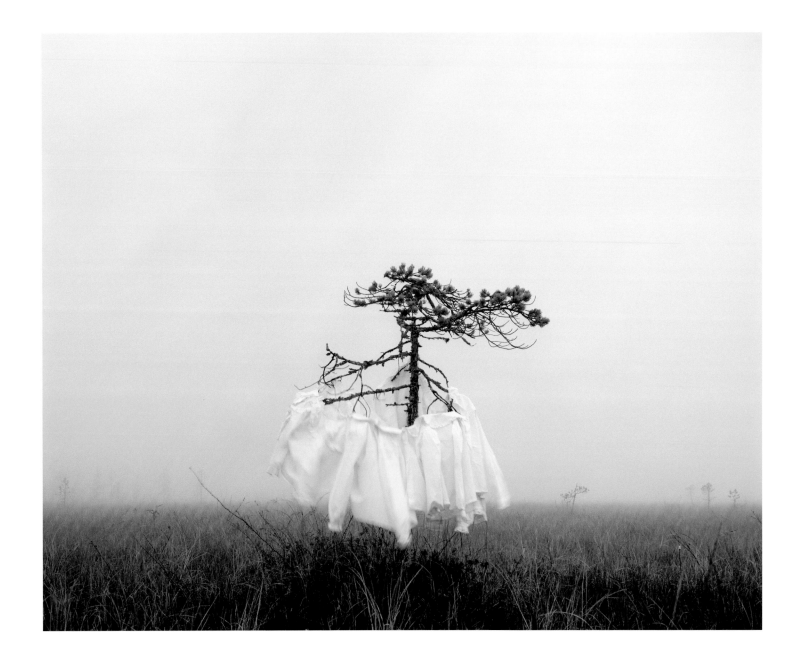

SHIELD, 2005, 100 x 125 cm / 72 x 90 cm, c-print/diasec

Riitta Päiväläinen

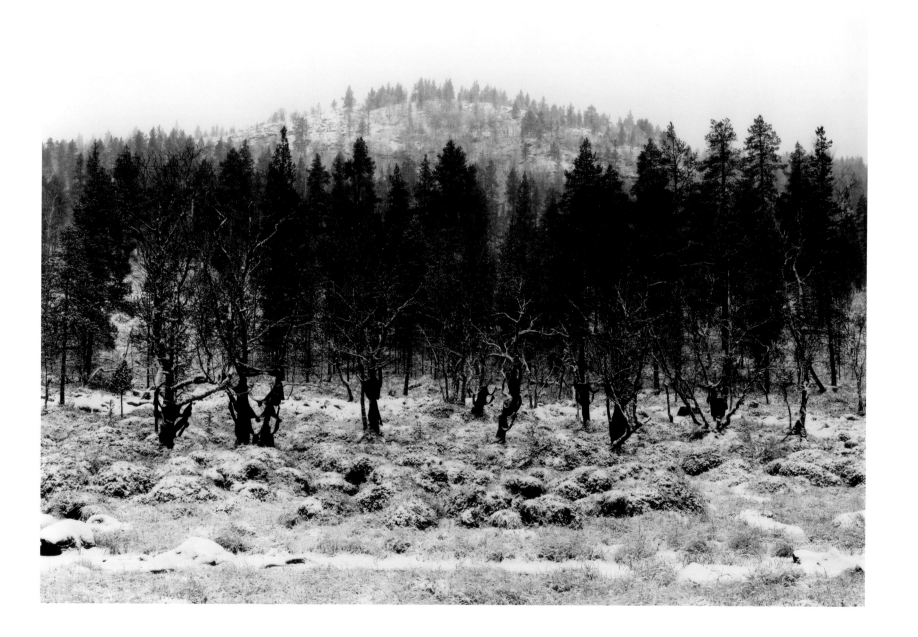

VEIL, 2004, 115 x 165 cm, c-print/diasec

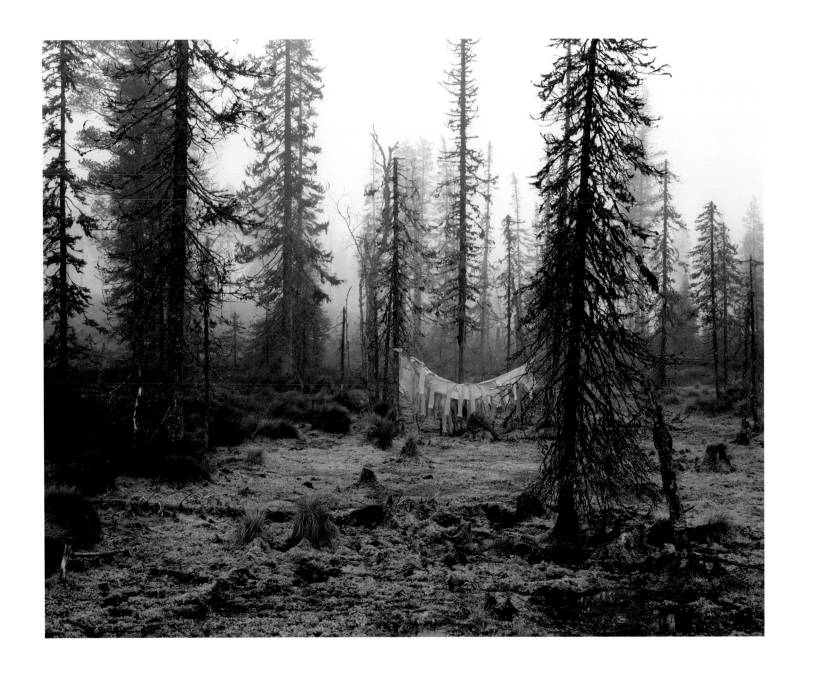

SHELTER, 2005, 100 x 125 cm / 72 x 90 cm, c-print/diasec

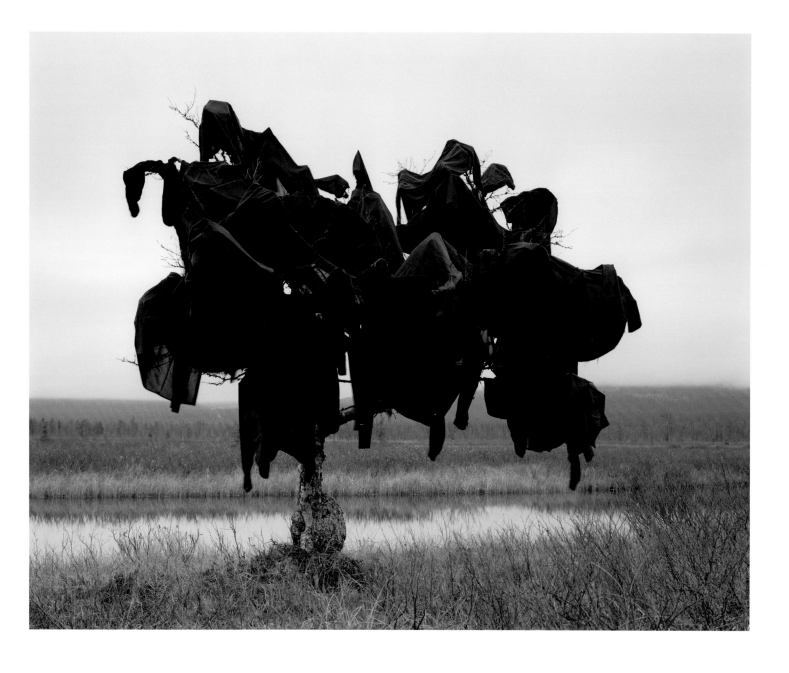

NEST, 2005, 100 x 125 cm / 72 x 90 cm, c-print/diasec

Anni Leppälä

Anni Leppälä's photographs are like visions. Fractured, open, associative, they trigger something in our mind which immediately connects us to our own memories.…

…Leppälä's images are anchored in a singular, specific moment, but the banal, everyday content of each of her photographs allows this moment to become timeless and her personal experience to become universal. Describing her approach, Leppälä states, "My pictures are attempts of recognizing and shedding light on obscure and vague movements. I want to approach the momentary quality of living through constancy. The paradox is that when you try to conserve or protect a moment by photographing it, you inevitably lose it at the same time."

More than just simple flashbacks in time, Leppälä's photographs also bear a kind of dreamlike quality. Looking at her photographs is like going through one's own mind "eyes wide shut." Déjà vu, dreams, fiction, or reality, one does not know, but still the image seems somehow familiar, part of our memory, of our life, or of our dreams. This openness lends the photographs the quality of fragile parts in an unfinished puzzle. Parts for which, in an effort to reconstruct the whole, we are led to search our minds. ▷ *Anni Leppälä was born 1981 in Helsinki. She graduated as a Bachelor of Arts from Turku Arts Academy in 2004 and is now preparing her Master of Arts degree at the University of Art and Design Helsinki.*

Anni Leppälä

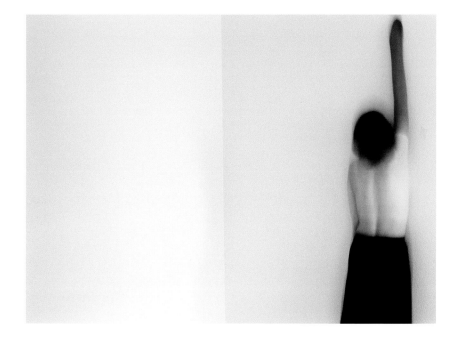

From the series *Seedlings (corner)*, 2005, 31.5 x 46.5 cm, c-print/aluminum
From the series *Seedlings (rowan tree)*, 2005, 31.5 x 21 cm, c-print/aluminum

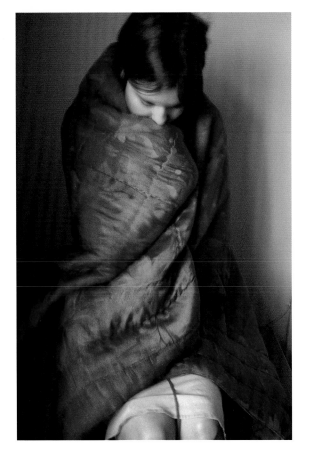

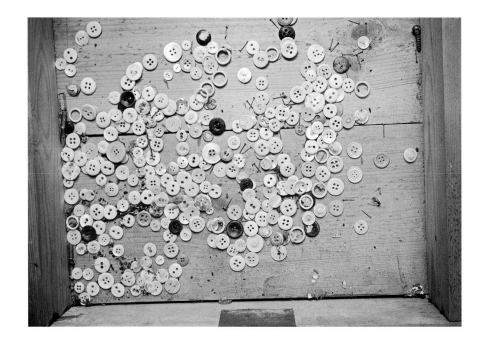

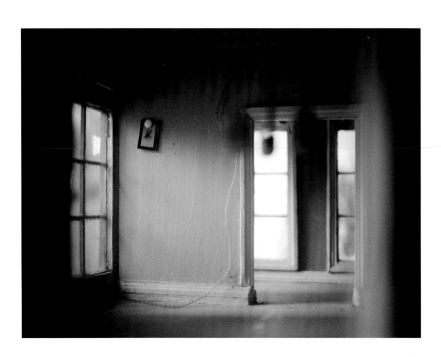

From the series *Seedlings (red blanket)*, 2004, 94 x 62.5 cm, c-print/aluminum
From the series *Seedlings (drawer with buttons)*, 2005, 21 x 30.5 cm, c-print/aluminum
From the series *Possibility of Constancy (dollhouse)*, 2005, 48 x 64 cm, c-print/aluminum

Anni Leppälä

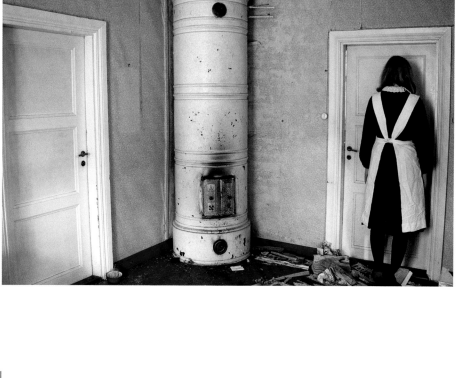

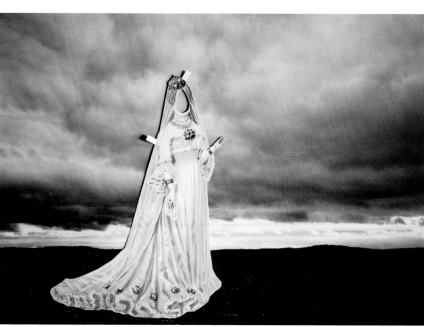

From the series *Seedlings (landscape)*, 2004, 21 x 31.5 cm / 47 x 69 cm, c-print/aluminum
The House, 2002, 31.5 x 47.5 cm, c-print/aluminum

From the series *Seedlings (buttons)*, 2004, 21 x 31.5 cm / 47 x 69 cm, c-print/aluminum
From the series *Seedlings (door)*, 2004, 21 x 30.5 cm / 62.5 x 94 cm, c-print/aluminum

Anni Leppälä

From the series *Seedlings (ribbon)*, 2004, 94 x 62.5 cm, c-print/aluminum
From the series *Seedlings (river)*, 2004, 47 x 69 cm, c-print/aluminum
From the series *Possibility of Constancy (curtains with birds)*, 2005, 21 x 30.5 cm, c-print/aluminum

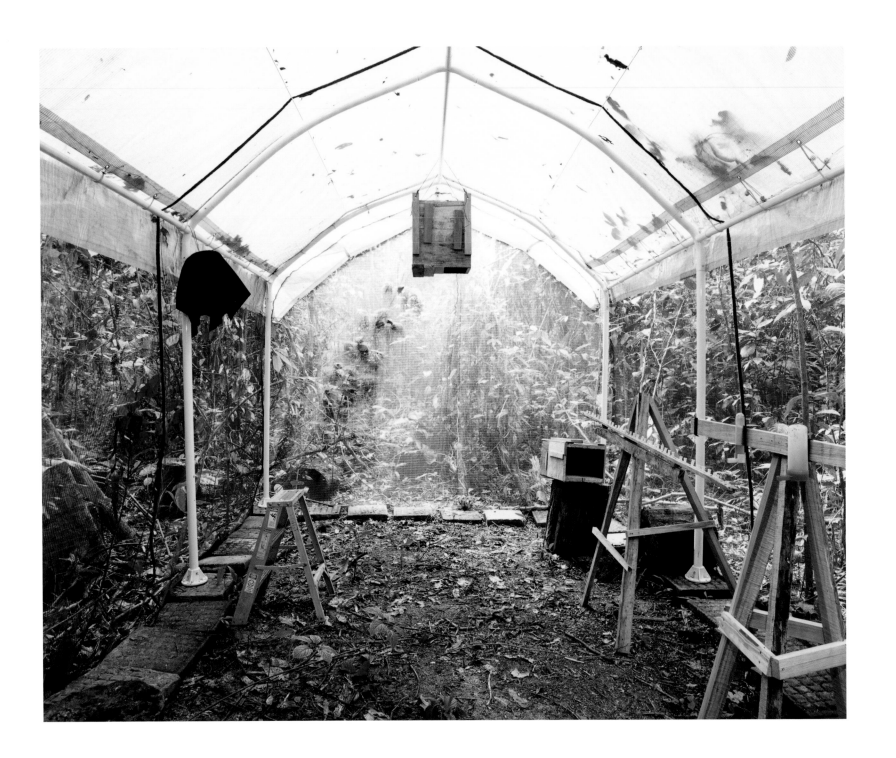

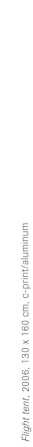

Flight tent, 2006, 130 x 160 cm, c-print/aluminum

In 1997, Sanna Kannisto began her series of photographs about the Amazon forest. She has returned there regularly ever since....

...In order to move about in this isolated part of the world, Kannisto usually attaches herself to scientific field stations, which provide her with a base from which to work.

Kannisto's photographs of the flora and fauna of the rain forest give us a glimpse of the beauty and mystery of these relatively unexplored parts of the world. Kannisto collects large varieties of the different species she encounters. She then studies and archives them; sometimes imitating the scientific approach, sometimes inventing methods of her own.

In making her photographs, whether they are landscapes, views of the field stations and research situations, self-portraits, or pictures of different species of plants and animals, Kannisto uses of a large variety of thematic approaches.

To photograph the various species of fauna and flora in a neutral surrounding, she even invented a little, showcase-like photo studio in which the subjects are placed, making them appear to be the protagonists of a miniature theater piece.

Living in, exploring, and documenting the rain forest, Kannisto has not only compiled a unique record of an enigmatic world, but has created a compelling narrative of a universe where the protagonists are frogs and snakes, fungus and orchids, insects and spiders. ▷ *Sanna Kannisto was born in 1974 in Hämeenlinna, Finland. She graduated from the University of Art and Design Helsinki in 2002.*

Sanna Kannisto

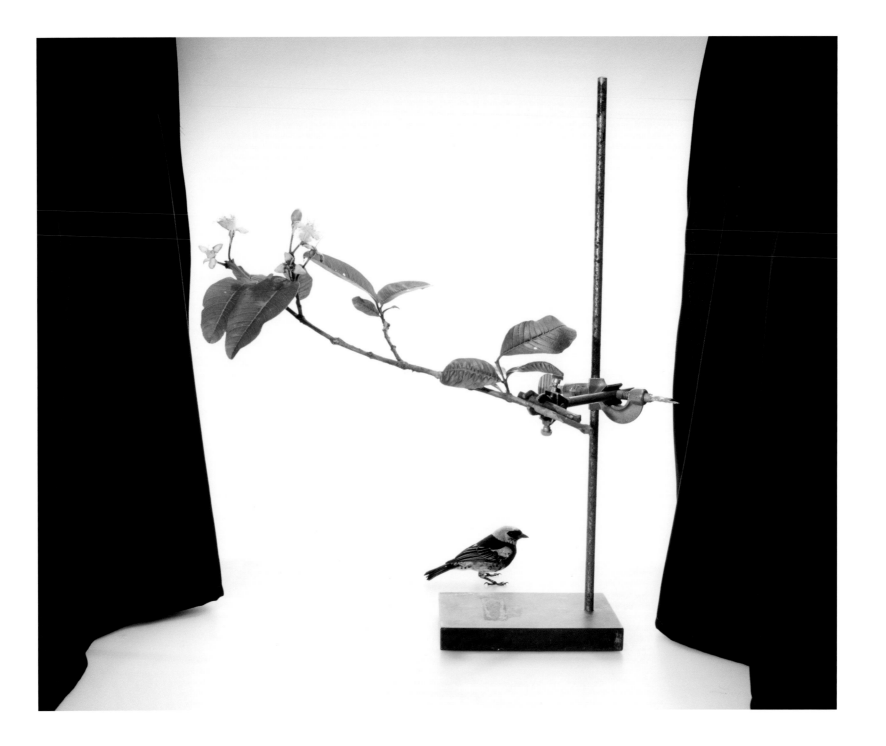

Tangara larvata, 2006, 74 x 93 cm, chromogenic print/aluminum

Leptophis ahaetulla, 2006, 74 x 93 cm, chromogenic print/aluminum

Sanna Kannisto

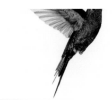

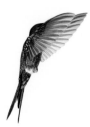

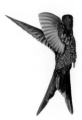

Sanna Kannisto

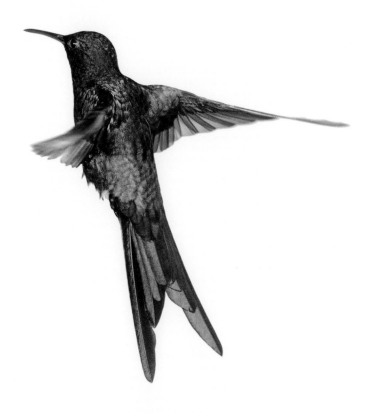

Hummingbird flight: Eupetomena macroura series 1-12, 2005, 44 x 56 cm, chromogenic print/diasec

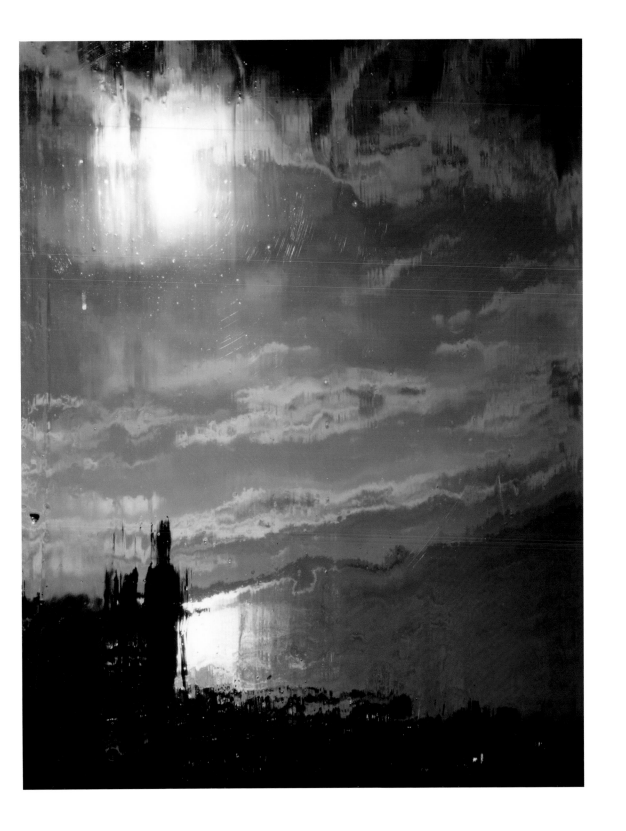

Jorma Puranen

The subjects of Jorma Puranen's work are history, culture, and identity. Puranen received international attention…

…for his conceptual photographs of landscapes, such as his series *Imaginary Homecoming*, from 1991 to 1997. Using historic photographs and texts from the archives of ethnological and anthropological museums, Puranen placed enlarged photographic images and texts into the northern landscape and re-photographed them in order to symbolize their origin and the ambiguous connection between culture and nature.

In his new series entitled *Icy Prospects*, Jorma Puranen combines his interest in the Nordic landscape with his interest in historical painting, which was the theme of his previous series entitled *Shadows, reflections and all that sort of thing*. Inspired by the varnished paintings of past centuries, he painted a piece of wooden board with black, glossy alkyd paint, to give it a reflecting, mirror-like texture. He then took the board outdoors into the icy northern landscape and photographed the fragmentary reflection of the landscape on the surface of the board. The result is a series of photographs which, due to the brushstrokes and the uneven surface of the board, mixed with the reflected landscape, have an extremely painterly appearance. In speaking of this new series, Jorma Puranen states that "This work is associated with new concepts of space, mobility, and distance that have emerged in cultural studies. I was interested in the possibility of a cultural space created by different fates, places, histories and encounters, a fictive historical world. *Icy Prospects* is a kind of fabric of facts, fantasy, geographical imagination, and intellectual landscapes." ▷ *Jorma Puranen was born in 1951 in Pyhäjoki, Finland. He graduated from the University of Art and Design Helsinki in 1978 and was a professor there from 1995 to 1998.*

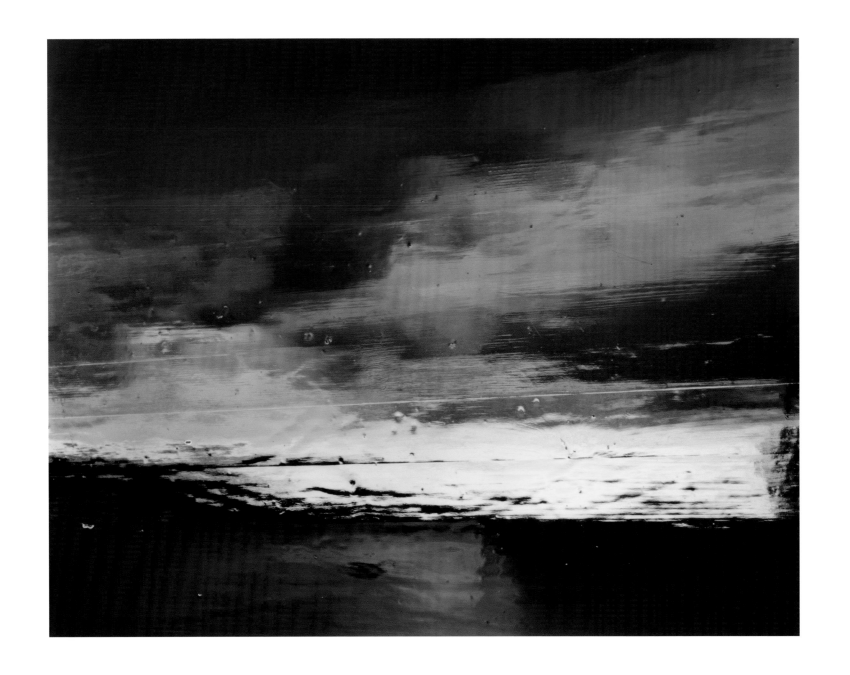

Icy Prospects 25, 2006, 130 x 170 cm, c-print/diasec

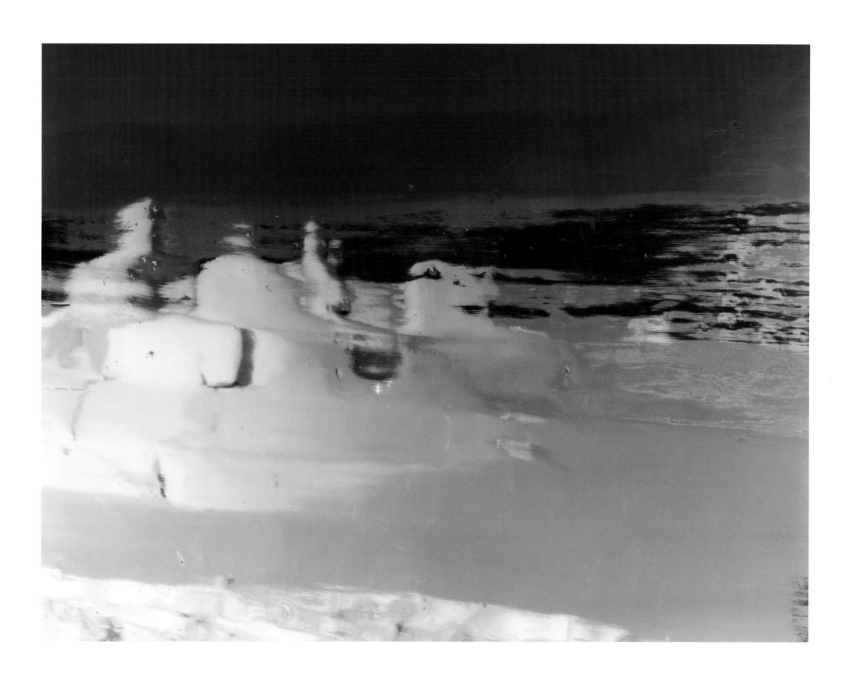

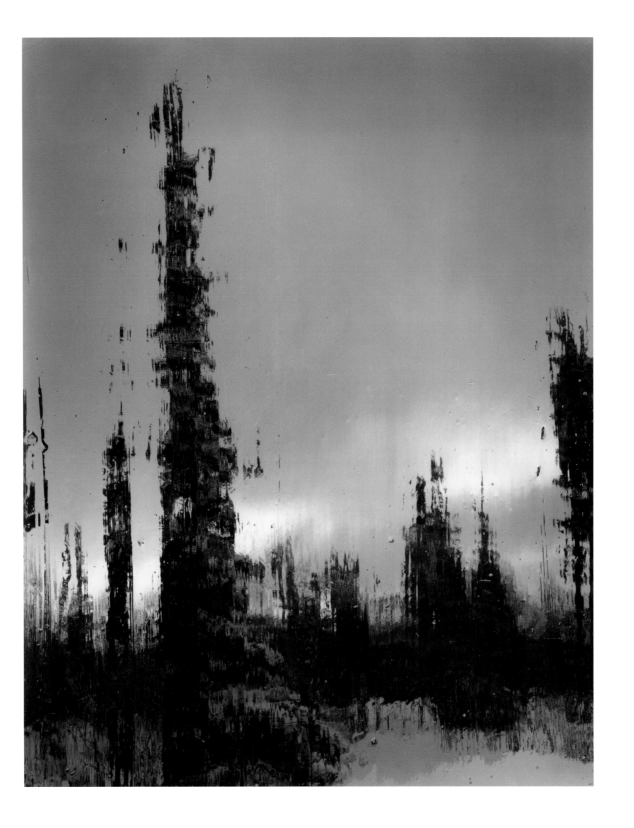

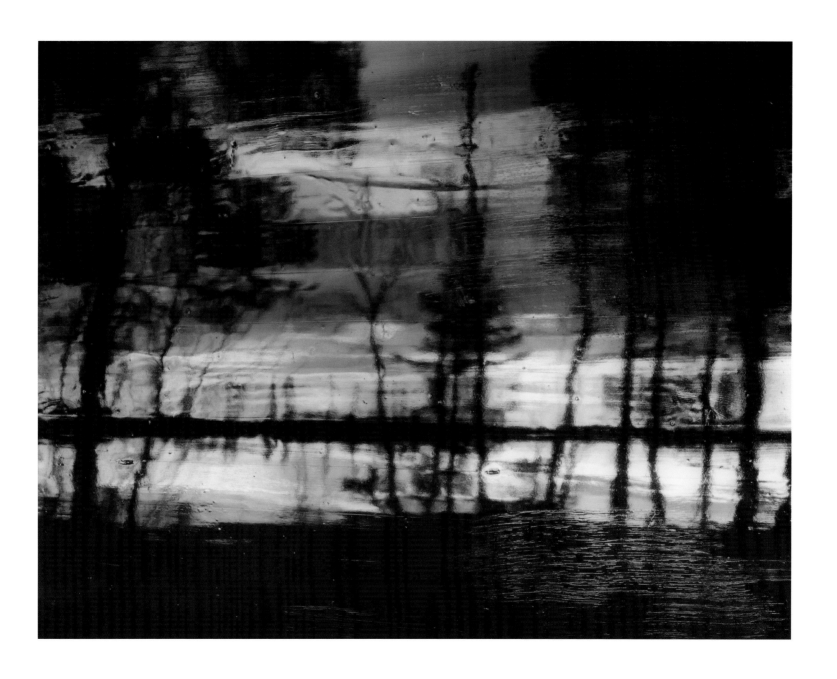

Janne Lehtinen

The dream of flying is one of mankind's oldest dreams. From Icarus and Leonardo da Vinci to modern aerial battles, men have invented machines to dive through the sky like birds and defeat the limitations of gravity....

...Janne Lehtinen is the artist as latter-day aviation pioneer. In his ongoing series of staged photographs entitled *Sacred Bird*, he can be seen standing in an elevated position–on a haystack, a tree, a boulder, or a diving board–with a curious "flight machine" either in his hands or strapped to his body, ready to leap into the void. The apparatuses he is wearing, or holding, are mostly very rudimentary self-made assemblages of assorted materials which resemble a parachute, a pair of wings, an engineless airplane, or some sort of wind machine. Looking at him, the viewer immediately deduces that the attempt will inevitably end in miserable failure. Yet the pictures, testimony to the dream behind this obsessive pursuit of flight, are marked by an oddly appealing sense of nobility. The absurdity of the young man's endeavor in his attempt to defeat the elementary laws of gravity, to say nothing of common sense, is at once hilarious and heartbreaking. One wonders whether the pictures are an elaborate satire on "the noble art of flying" or the simple dreams of a fool.

Sacred Bird is also an autobiographical exploration; Lehtinen's father is a well-known Finnish glider pilot. While acting out the Oedipal complex in a humorous manner, the pictures are also a beautiful homage to his father, to the myth of flying, and to the Finnish landscape.

▷ *Janne Lehtinen was born in 1970 in Karhula, Finland. He graduated from the University of Art and Design Helsinki in 2002.*

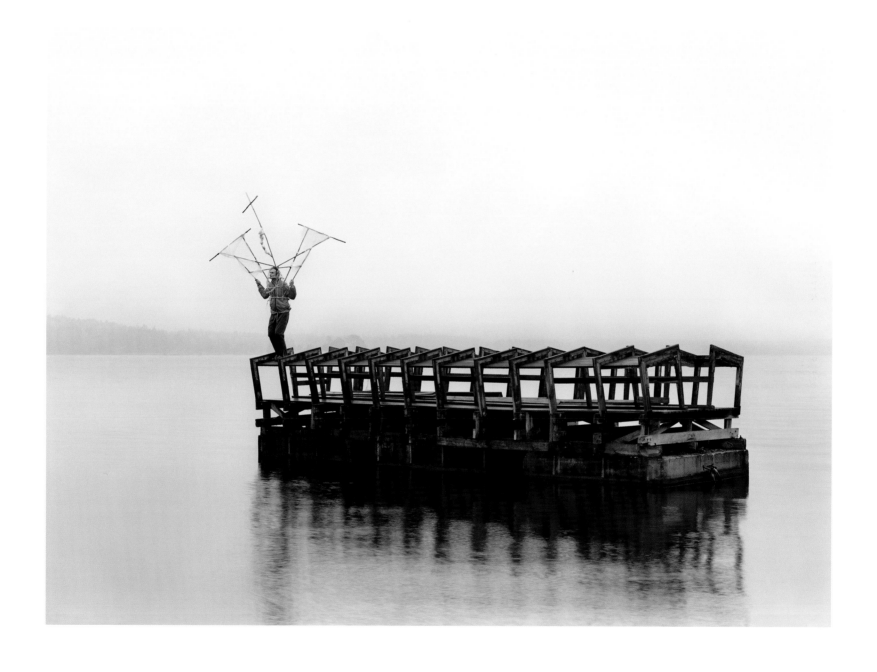

Cage, 2004, 100 x 137 cm, c-print/aluminum

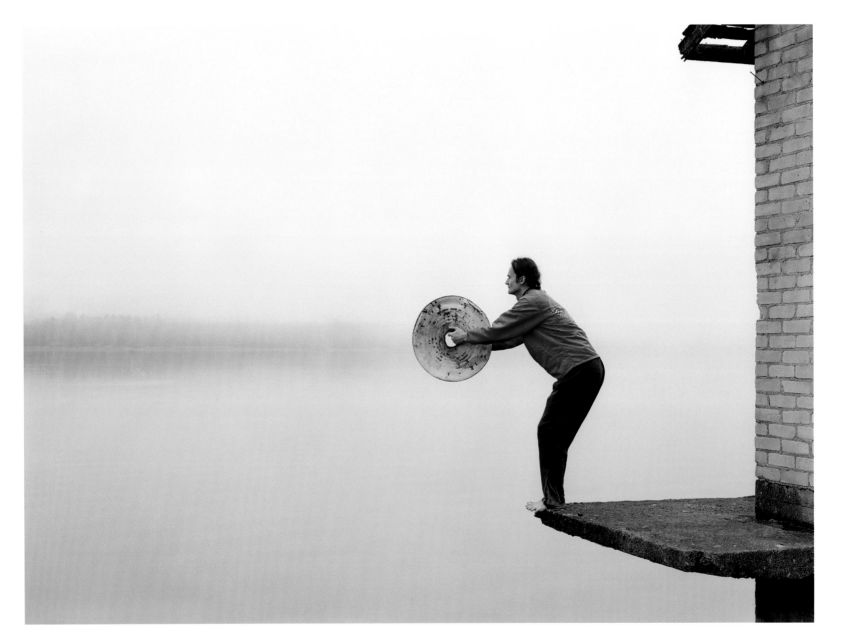

Edge. 2005, 100 x 137 cm, c-print/aluminum

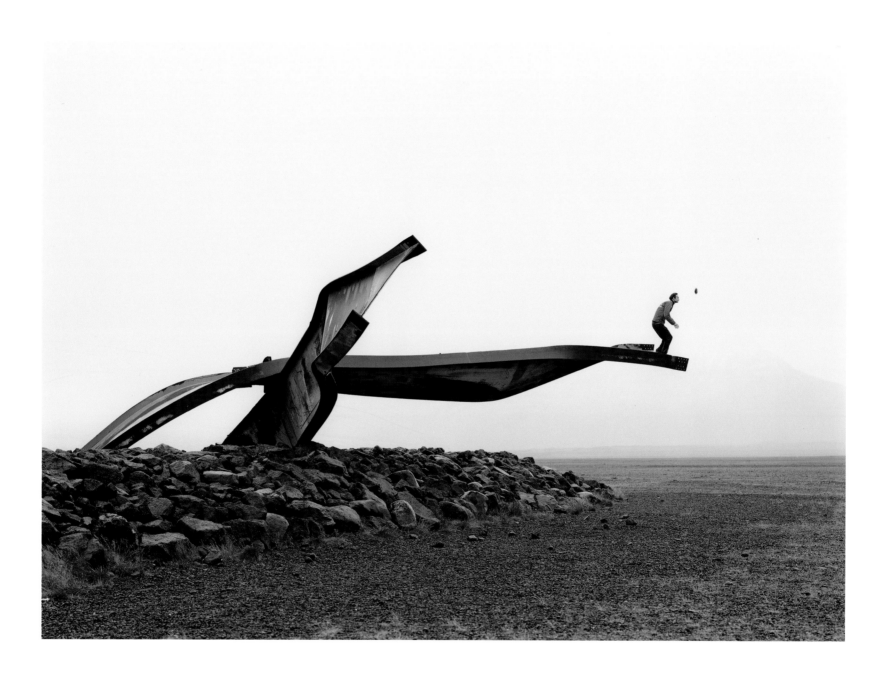

Bridge Falling, 2005, 100 x 137 cm, c-print/aluminum

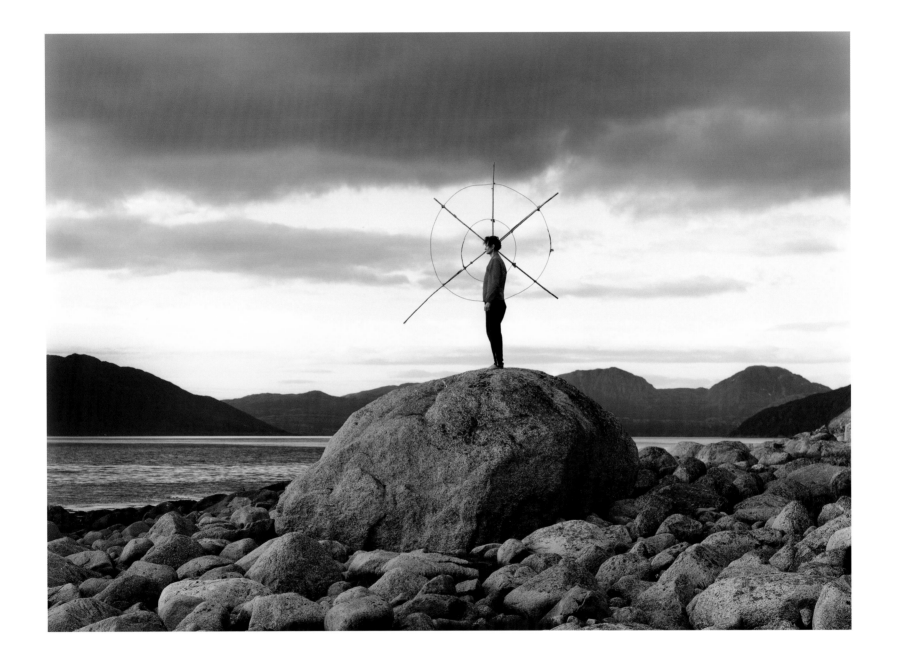

Circle, 2006, 100 x 137 cm, c-print/aluminum

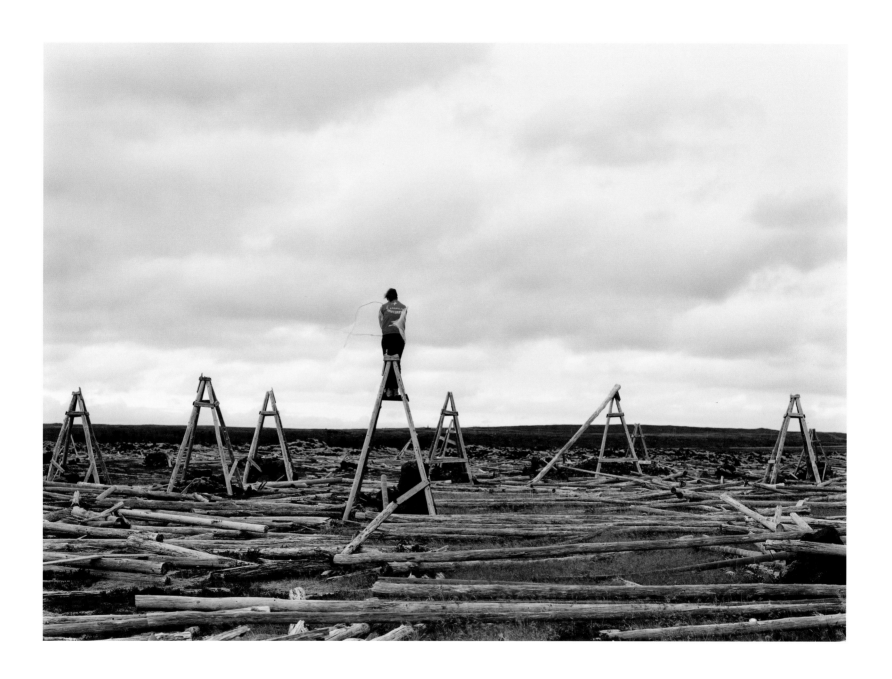

Woodland, 2005, 100 x 137 cm, c-print/aluminum

In past centuries, night meant darkness and the cessation of all activity. Night also was the "other part" of the day in which dark forces reigned.…

…It was only in the nineteenth century that gas lights were invented and installed in the larger cities of the world. Photography, also an invention of that time, lent itself to the development of the theme of the nightscape.

Defining Darkness is the title which Ea Vasko has given to her latest project in which the artist works with our perception of space through light. The starting point for her uncanny night pictures was a specific visual experience she had while laying sleepless, in a dark bedroom, peering at the dim space surrounding her.

Her pictures are nearly abstract and one can only guess at the lines of a room, the shimmering lights of a city at night, or parts of a building. In removing all of the easily recognizable elements from the pictures, she renders the perception of the image unclear. In order to obtain this effect, Vasko combines photographs of real places with those of scale models. In turn, the viewer, with references to both elements, finds enough "recognizable" elements in order to enter into Vasko's abstract night fictions. ▷ *Ea Vasko was born in Helsinki in 1980. She graduated as a Bachelor of Arts from the University of Art and Design Helsinki in 2004 and is now studying for her Master of Arts degree.*

Ea Vasko

Ea Vasko

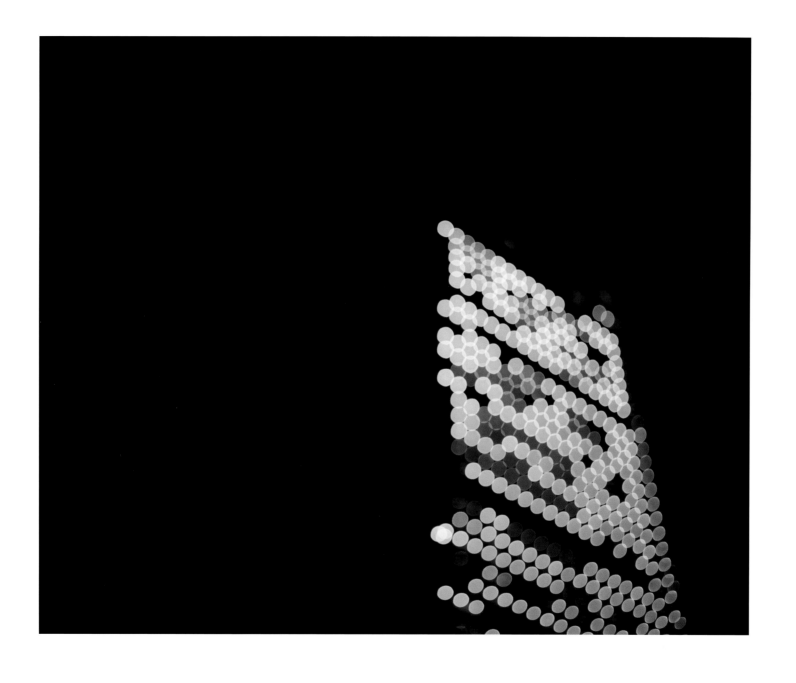

City / Order II from the series *Defining Darkness*, 2006, 75 x 90 cm, c-print/aluminum

Study VI from the series *Defining Darkness*, 2005, 75 x 90 cm, c-print/aluminum

5.1 from the series Translucents, 2004, 75 x 90 cm, c-print/aluminum

5.4 from the series Translucents, *2005, 75 x 90 cm, c-print/aluminum*

City / Disorder II from the series *Defining Darkness*, 2006, 100 x 120 cm, c-print/aluminum

Heli Rekula

The work of Heli Rekula consists of two major series, the landscape and the staged image. The artist works with these themes…

…through both photography and video. Rekula's landscapes are vistas of the North, characterized by cool, modulated colors and the pale light of the Nordic latitudes. The pictures are notable for their sheer beauty and the artist's mastery of the medium. Their beauty and clarity enables them to transcend the banal reflection of reality and take on symbolic meaning. Studying them closely one can see that they have clear affinities with eighteenth-century romantic landscape painting, such as the spiritually charged works of Caspar David Friedrich. In Rekula's staged images figures face the camera as they perform pre-assigned roles in front of simple, uniform backgrounds. There is nothing in the picture to distract the viewer from a direct relationship to the figure. But unlike the landscapes which may be read on multiple levels, the staged images, while exploring issues associated with identity, sexuality, and gender, are clearly constrained to an emotional level of interpretation.

Though the two series are very different in their thematic and visual approach, they share the same kind of cool distance and symbolic overtones. Always exhibited together, each of the series speaks its own language while, at the same time, engaging in dialogue with the other.

▷ *Heli Rekula was born in 1963 in Helsinki, Finland. She graduated from the Lahti Institute of Design in 1991 and is currently attending to postgraduate studies at the Academy of Fine Arts in Helsinki. Heli Rekula has been teaching at the University of Art and Design Helsinki since 1999.*

Desire (Pain), 2004, 80 x 65 cm, c-print/diasec

The Double (Passing), 2006, 160 x 120 cm, c-print/diasec

Landscape no. 39 Héphaestos, 2006, 160 x 213 cm, c-print/diasec

Stage II, 2006, 160 x 120 cm, c-print/diasec

Ulla Jokisalo

In her work, Ulla Jokisalo explores the way in which memory and childhood experiences influence our understanding of identity….

…Her pictures are imprinted with nostalgia and childhood memories associated with play and the imaginary. Objects and images form the basis of her artistic vocabulary. To create her works, Ulla Jokisalo uses photography in a very original way. In a recent interview she explained: "Photography is a perfect support for my work, given its narrative aspect. Each photograph is a narrative in itself. Nonetheless, I also attempt to express my perception of reality and to develop my own imaginary language through my work. That is why my photographs are often embroidered or cut out. I also integrate threads in my works. This approach has the advantage of being both concrete and abstract, allowing me to reproduce my imaginary ideas in a more eclectic way."

Most of the photographs Ulla Jokisalo uses in her assemblages and collages are collected from family albums and magazines.

The recurrent use of sewing techniques and fabric in her work is a direct reference to her mother, who was a seamstress. Cutting, sewing, and stitching become gestures connecting her to her mother, and us to the notion of conscious and unconscious levels of identity and gender.

▷ *Ulla Jokisalo was born in 1955 in Kannus, Finland. She has been a professor at the University of Art and Design Helsinki since 2002.*

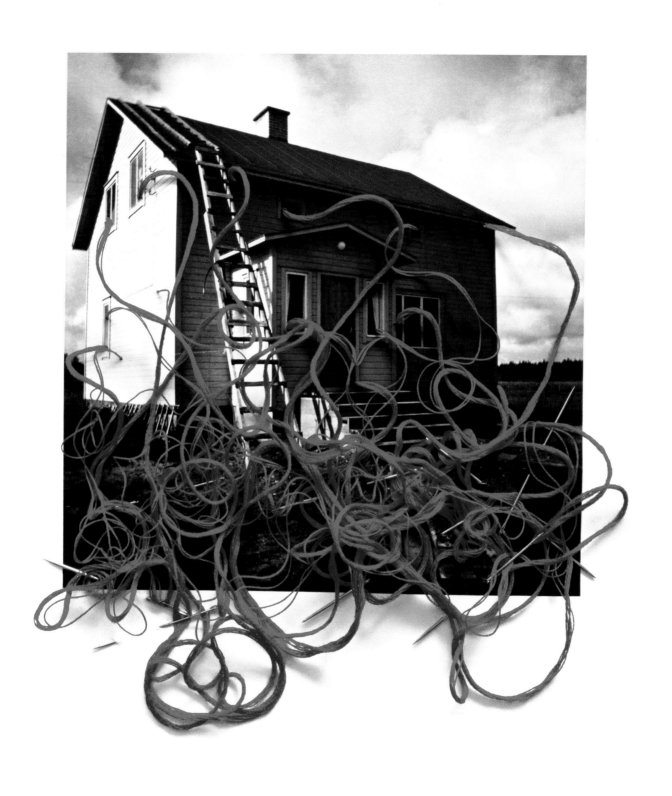

Ulla Jokisalo

Inspiration, 2005, giclee print, dimensions variable (original 1999, thread and needle on gelatin silver print)

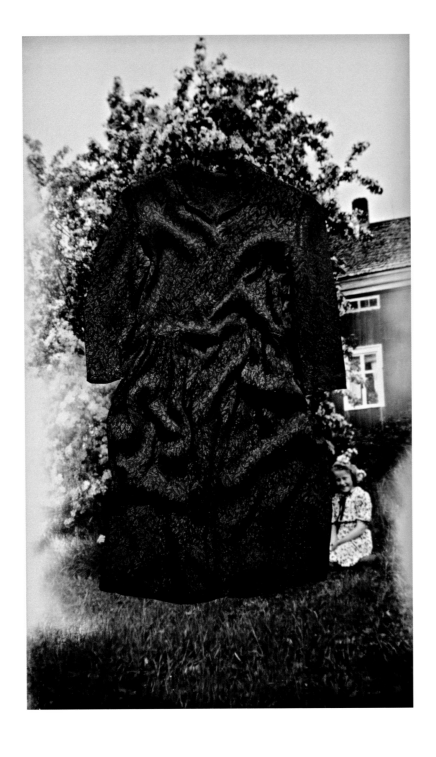

Blue dress, 2005, giclee print, dimensions variable (original 1997, gelatin silver and chromogenic print)

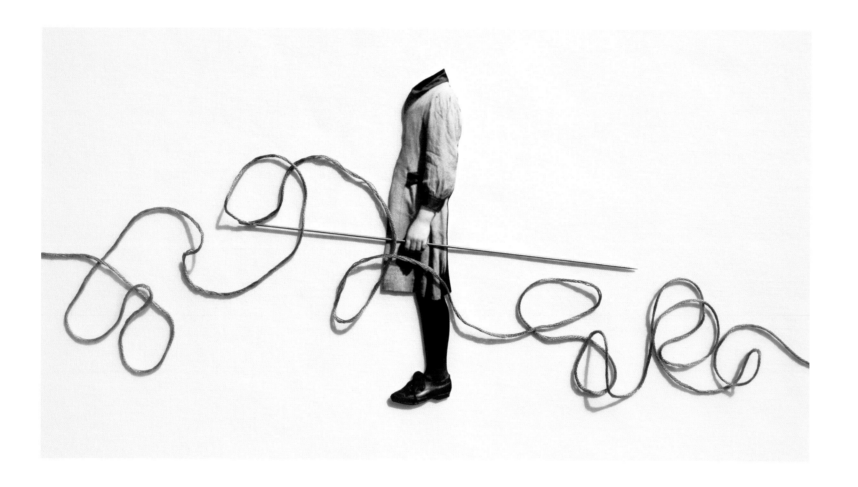

Needle bearer, 2006, giclee print, dimensions variable (original 2005, giclee print, needle and thread on canvas)

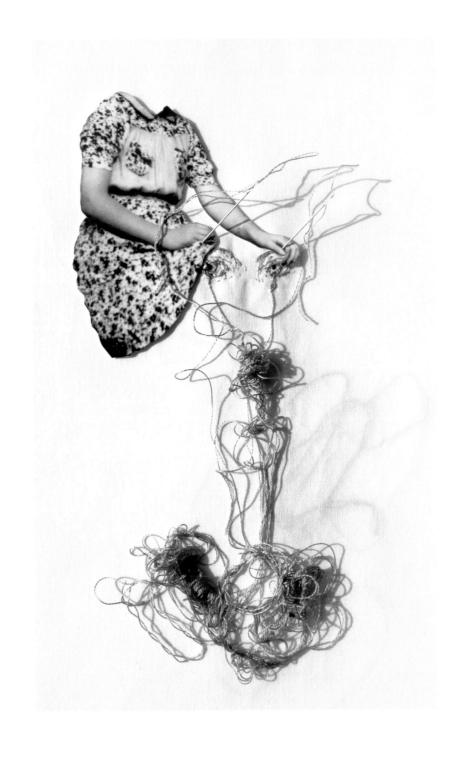

View, 2006, giclee print, dimensions variable (original 2006, giclee print, needle, thread and embroidery on canvas)

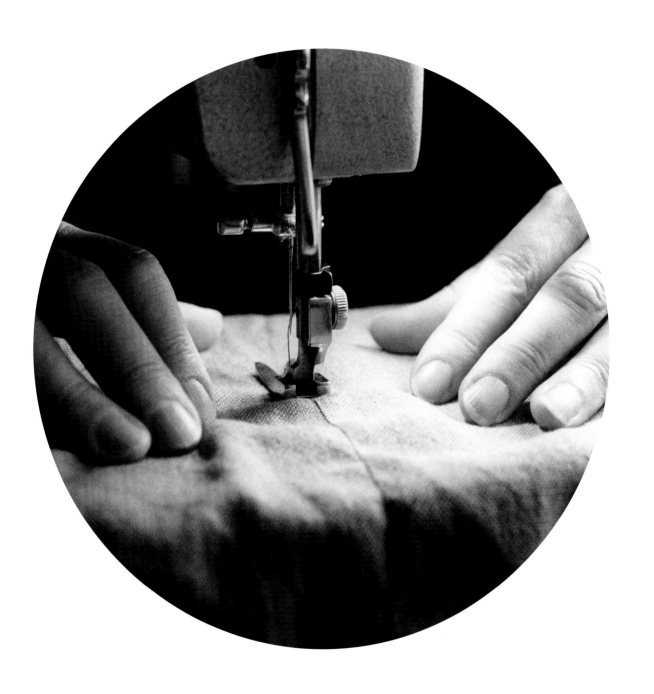

My Mother was a Dressmaker, 2005, giclee print, dimensions variable (original 1995, gelatin silver print)

Ulla Jokisalo

New Graffiti # 2 (Churchyard), 2005, 158 x 200 cm, c-print/diasec

Nanna Hänninen

Nanna Hänninen's
New Landscapes work in
part like a short movie,
mixing lights in the scenery
with long exposures with
the camera....

…These urban landscapes are drawings of her body movements that are captured on the photographic material as rhythmic lines of light where the subject and the scenery melt into a single image. These pictorial motifs are divided into two different levels, the abstract and the actual, merging the human presence (breathing, heartbeat, laughter, talking, and walking during the time of exposure) into a photographic media that more closely resembles painting.

Hänninen's *The New Landscapes* series follows her sociological interest in the individual who is sensing, understanding, and placing herself in the outside world. These photographs become concentrated narrations of the moment and work as large color abstractions that have a more profound significance of the surrounding reality.

▷ *Nanna Hänninen was born in 1973 in Rovaniemi, Finland. She graduated from the University of Art and Design Helsinki in 2002.*

Jyväskylä Skyline # 1 (laughing), 2006, 158 x 200 cm, c-print/diasec

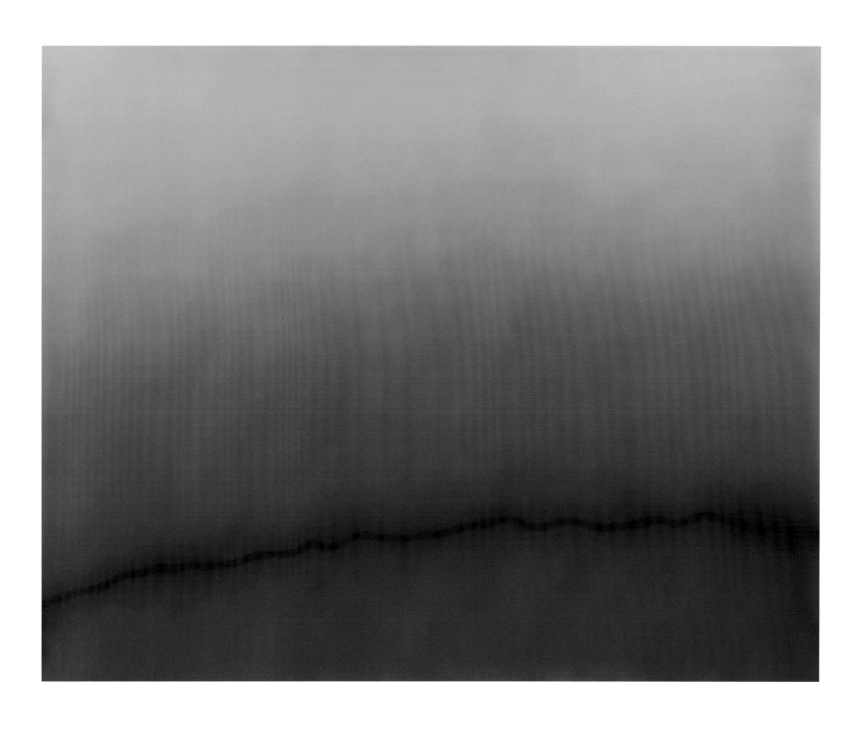

Foggy Scene I, 2005, 158 x 200 cm, c-print/diasec

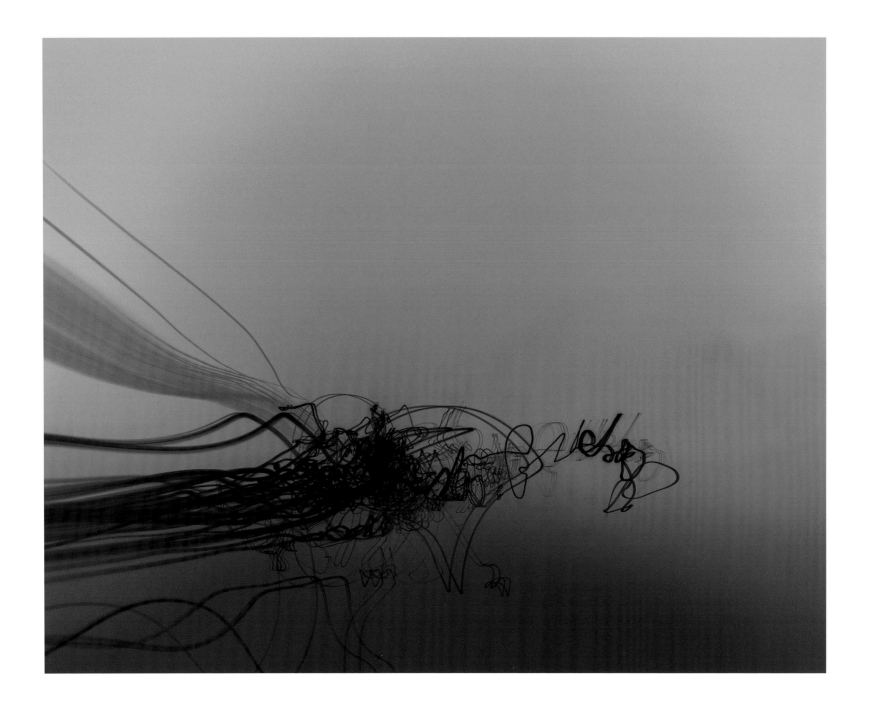

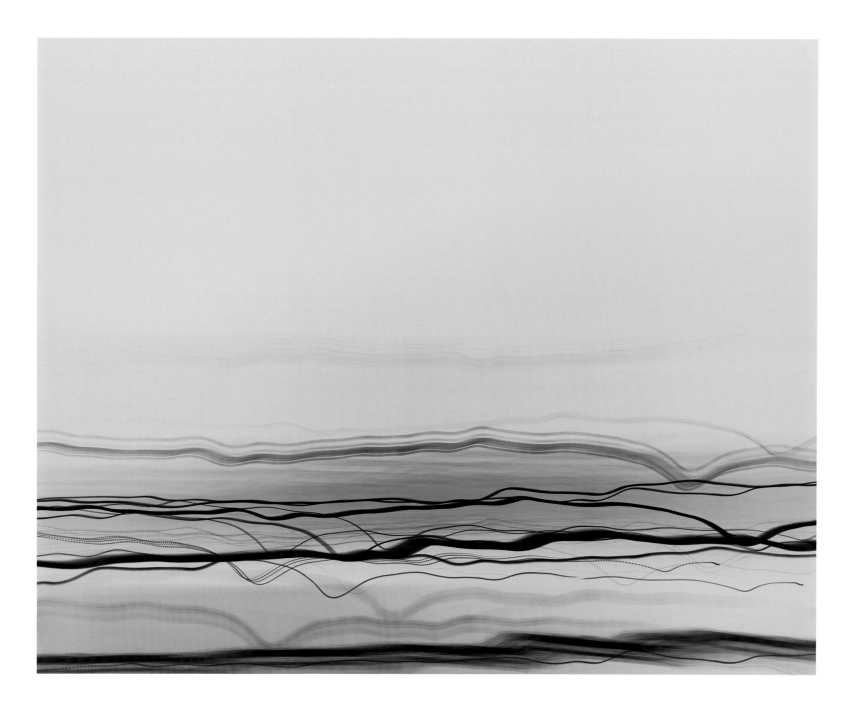

Townhall of Kuopio (breathing), 2005, 110 x 140 cm, c-print/diasec

Nanna Hänninen

In her photographs,
Susanna Majuri questions
our notion of "the real."
She does so by shedding a
new and disturbing light…

…on all that looks familiar. Her subjects are anchored in places the viewer can relate to, but these places are associated with situations which do not exist in the real world.

For her photographs, Susanna Majuri creates short narrative scenes, like film stills. Sometimes peculiar, sometimes bizarre, or even "surreal," her images are ambiguous in that the viewer can only imagine that which remains outside of the frame, and give the impression that we only get parts of what must be a bigger story. Instead of relating a specific story, Susanna Majuri suggests multiple psychologically and symbolically charged scenarios.

The water in her photographs works as an emotional conduit. Her earlier works were photographs below the waterline as she was distorting the perspective of "being." Majuri's later works bring the subject out of the water and into the real world, letting them reflect the ambiguities their actions are assuming.

In her series *You Nordic*, which was her diploma work for the University of Art and Design in Helsinki, Susanna Majuri portrays people in Iceland, Denmark, Norway, and Sweden, but leaves it up to the viewer to create his or her own "stories of the North." ▷ *Susanna Majuri was born 1978 in Helsinki. She graduated as a Bachelor of Arts from Turku Art Academy in 2004 and is now preparing her Master of Arts degree at the University of Art and Design Helsinki.*

Susanna Majuri

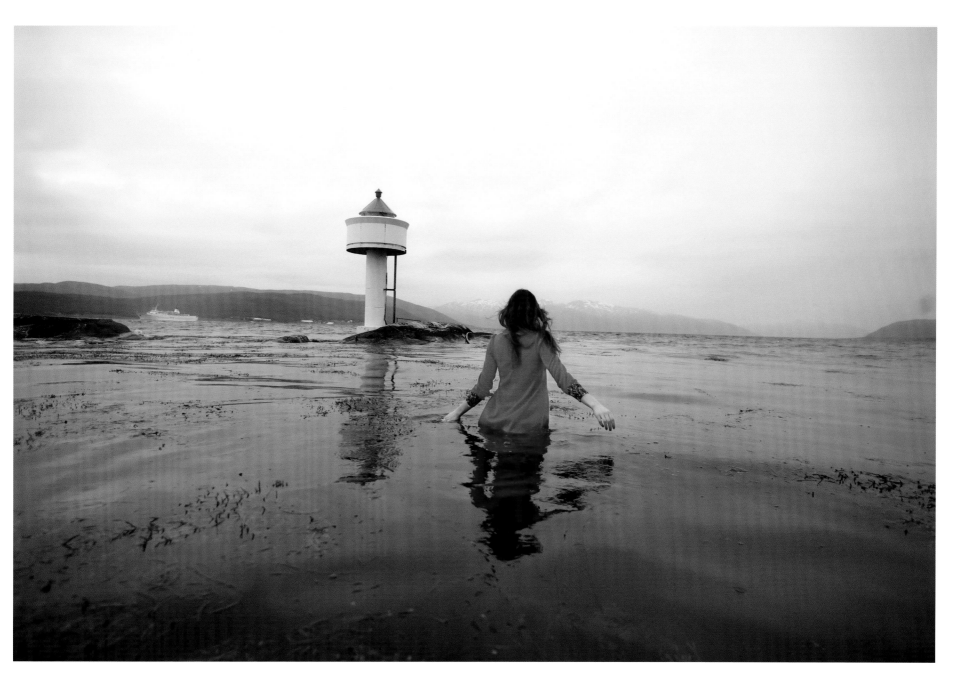

Susanna Majuri

Elskar fyr (Hide Tide), 2006, 90 x 135 cm, c-print/aluminum

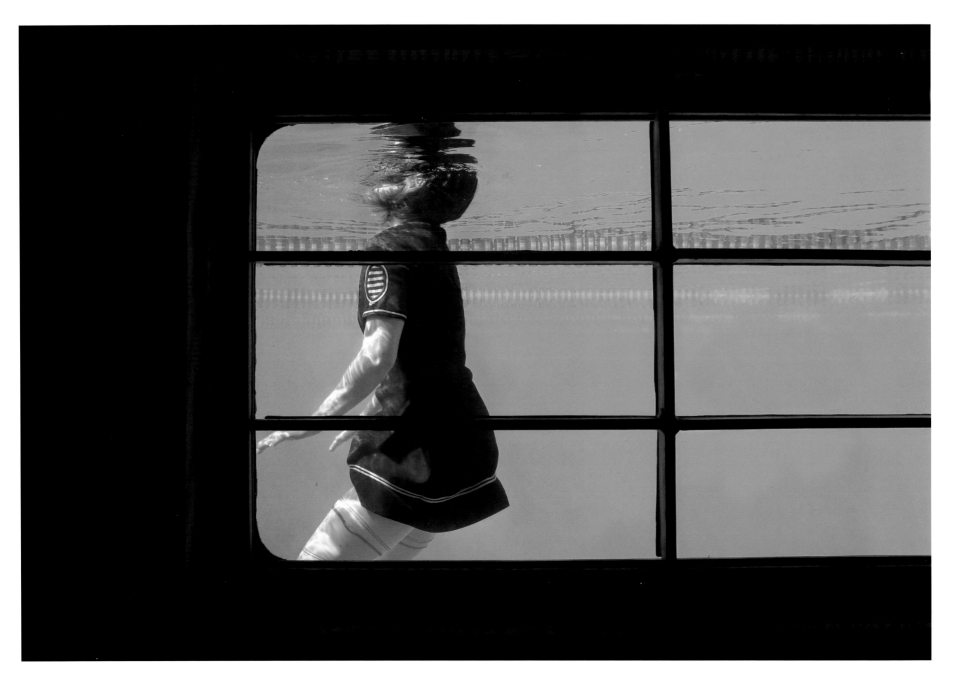

Dear Sailor, 2005, 80 x 120 cm, c-print/aluminum

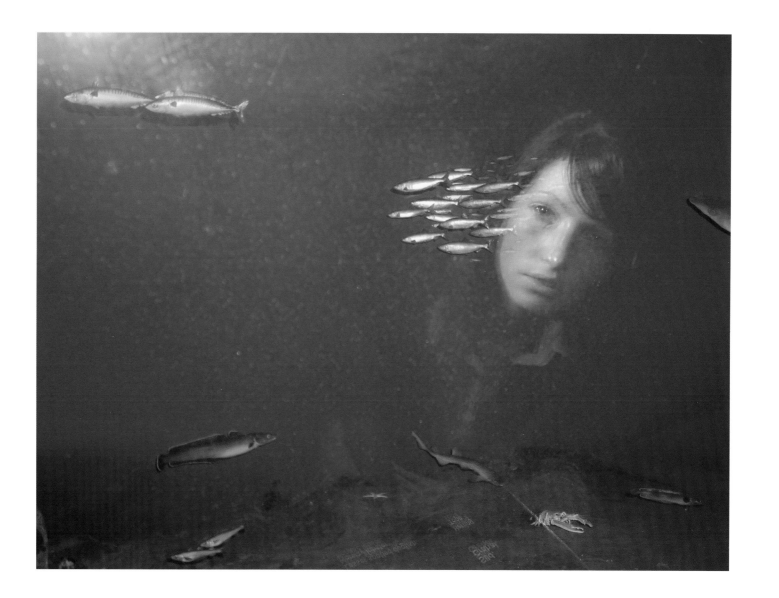

Susanna Majuri

Fisherette, 2005, 40 x 53 cm, c-print/aluminum

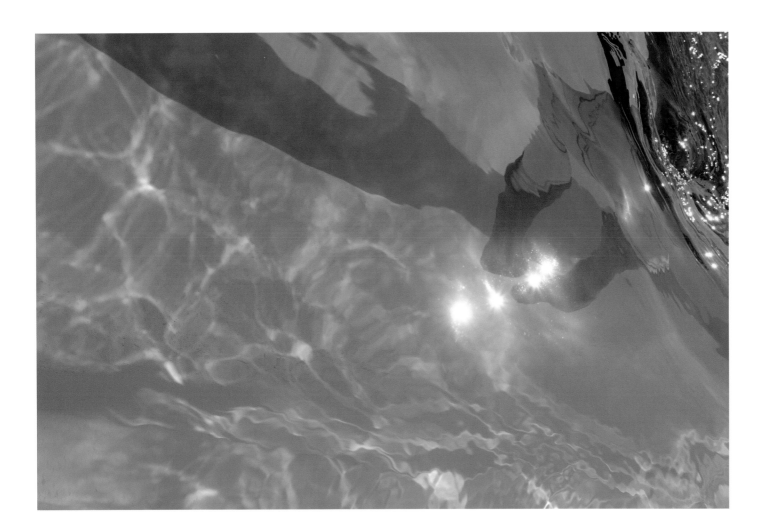

Goldfeet, 2005, 80 x 120 cm, c-print/aluminum

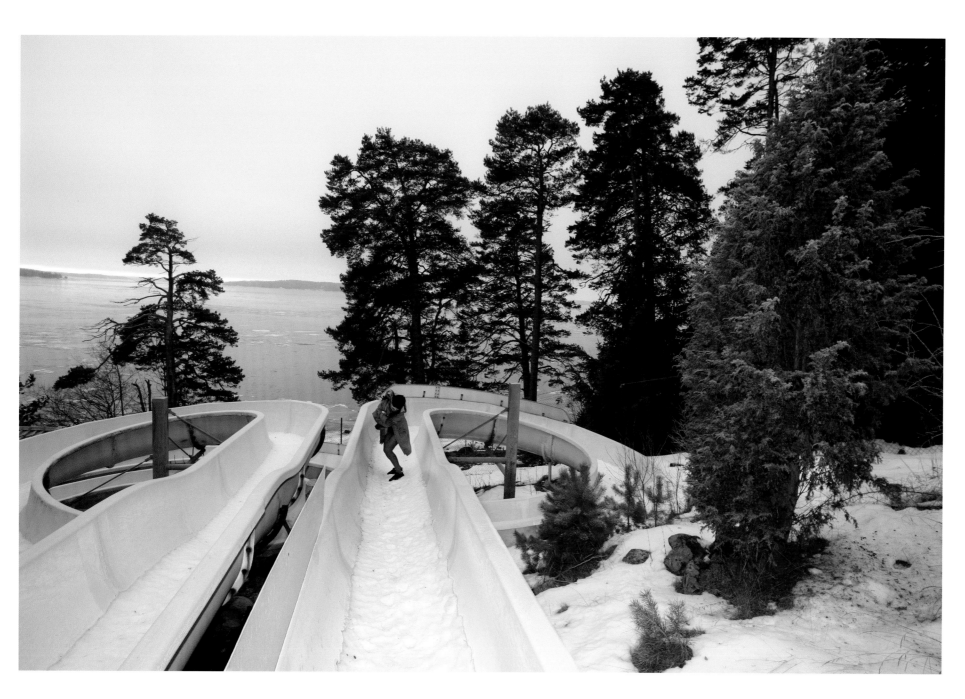

Camouflage, 2006, 80 x 120 cm, c-print/aluminum

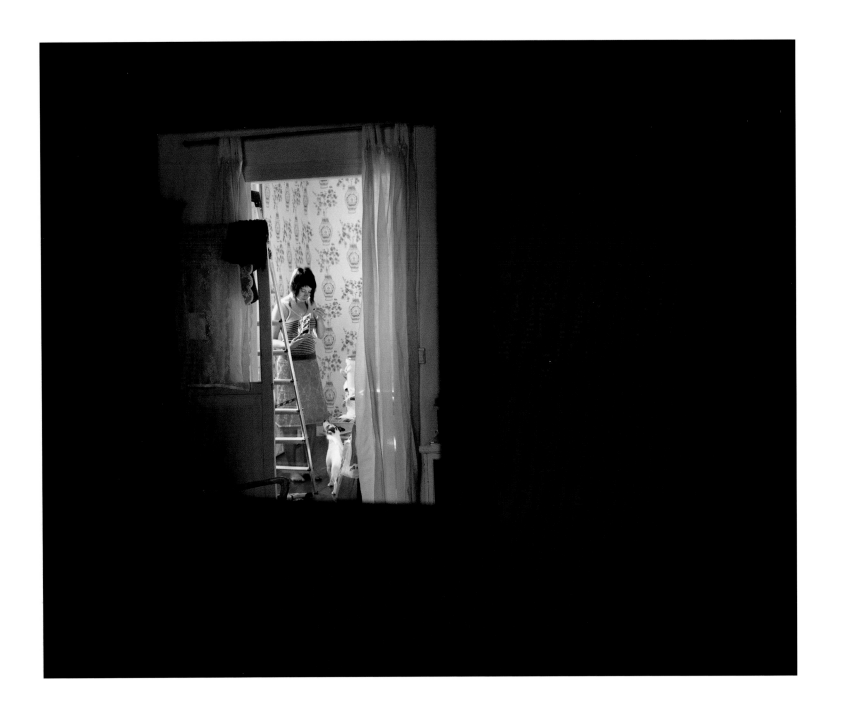

Aada eating candy at home, Turku, 2006, 80 x 100 cm, c-print/aluminum

Maarit Hohteri

Maarit Hohteri photographs her life and the people around her. She records facts and emotions from moments in her personal experience…

…that are not necessarily of particular interest. She collects images of her private life that constitute a sort of visual diary, a personal archive which ranges from the beginnings of her studies at the University of Art and Design Helsinki up to the present day.

If Hohteri's snapshot-like photographs are formally related to the work of the American photographer Nan Goldin, her subject matter is very different. Compared to the world represented in Nan Goldin's work which usually portrays people living on society's edge (drug addicts, homosexuals, transvestites, etc.), Hohteri's world is less violent and destructive. Populated by young Finnish bohemians who, with their oddly colored hair, piercings, and tattoos, look more provocative than they really are, Hohteri's milieu is more protected and innocent than that of her famous peer.

Hohteri recounts the story of her life with her family and friends through photographs of both banal and special events. Following her direction, the viewer meets people, participates in parties and discussions, gets to know life at the university, or witnesses girls' beauty naps. The people, the places, and the emotions in the photographs are all authentic; even though some situations are staged for the camera. Hohteri is a witness to these events. Her work is not only a precious record of her life, but also a chronicle of her generation and her country.

▷ *Maarit Hohteri was born in 1976 in Helsinki, Finland. She graduated from the University of Art and Design Helsinki in 2002.*

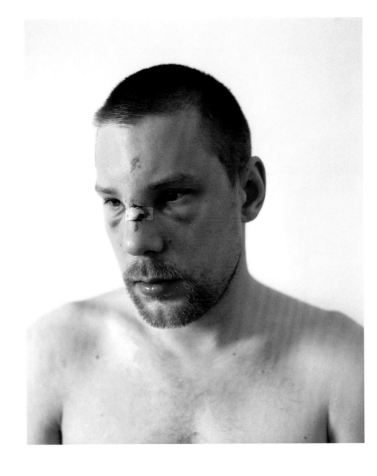

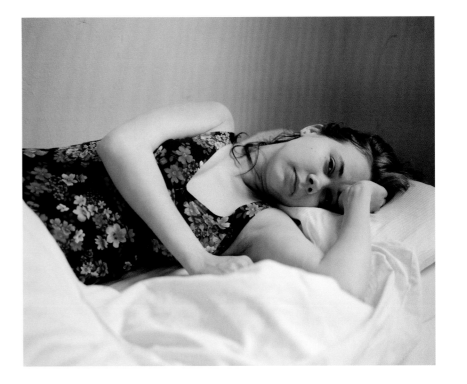

Kukka, Hamburg 2005, 80 x 100 cm, c-print/aluminum
Pekka, 2004, 100 x 80 cm, c-print/aluminum

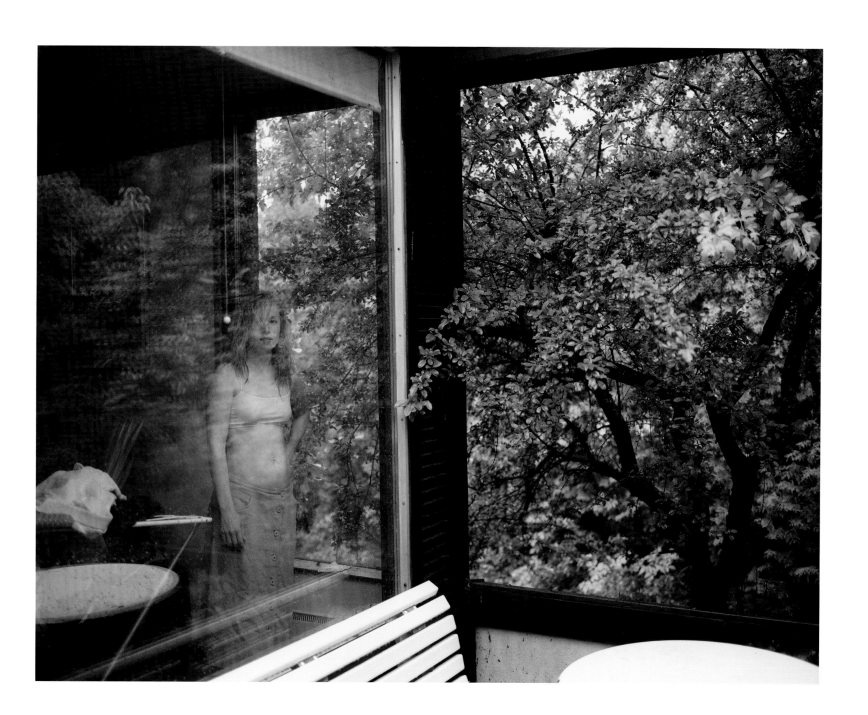

Satu in bedroom, 2004, 88 x 110 cm, c-print/aluminum

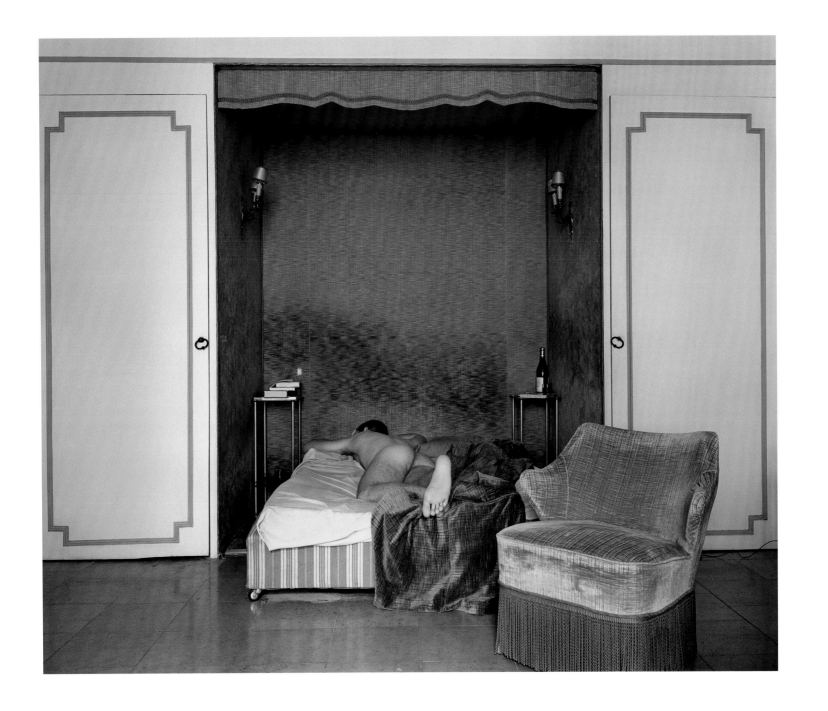

Joonas sleeping, Paris 2002, 80 x 100 cm, c-print/aluminum

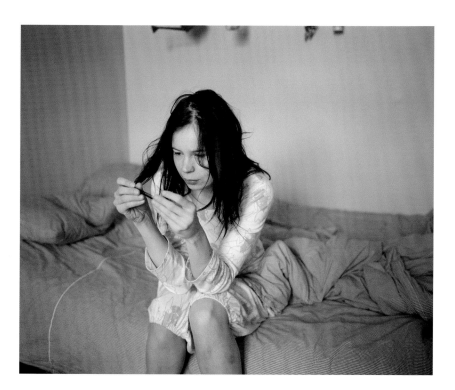

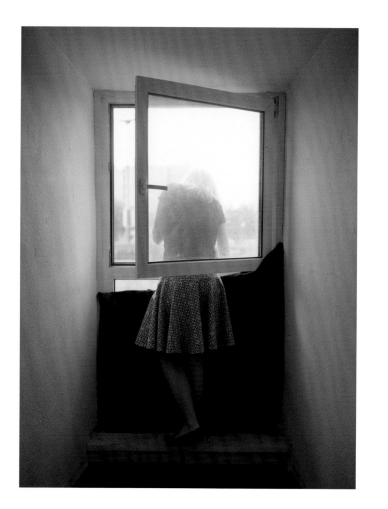

Aada at my studio, 2004, 80 x 100 cm, c-print/aluminum
Anke having a smoke, Hamburg 2005, 100 x 80 cm, c-print/aluminum

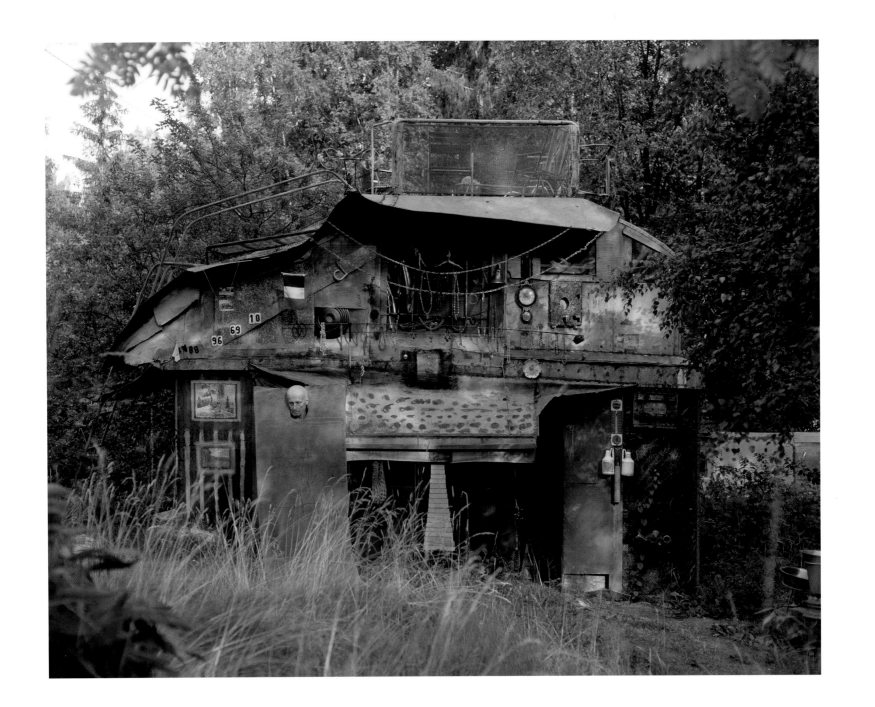

Untitled, 1988, 65 x 80 cm, lambda print

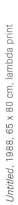

Jan Kaila met Elis Sinistö
(1985–2004) for the first time
when he was still a child.
Sinistö was then already living
on a piece of land…

…in Kirkkonummi (Northern Finland) which he had bought in the nineteen-fifties and which was to become his home and the "artwork" on which he worked until his death. He built more than ten large cottages on his lot, as well as several swings and numerous other kinds of sculptural/practical constructions and monuments.

In 1985 Kaila approached Sinistö for the first time with the idea of doing a photographic project and, until Sinistö's death in 2004, returned to the place more or less regularly in order to photograph, and later to film, the life and the work of Sinistö. In the beginning his approach, that of a documentary photographer, was to describe Sinistö's bohemian and somehow strange life in the middle of his *Gesamtkunstwerk*. Later in the process of the project, between 1988 and 1991, Kaila adopted a new, more conceptual direction, and began a collaboration with Sinistö who began to stage for him. This collaboration was central to Kaila's artistic development which, in evolving from a documentary form into a more conceptual form, became more personal and took on experimental attributes.

Kaila's portraits of Elis Sinistö, while delving deeply into the complexities of the human mind, are a stunning testimony of the complicity and mutual respect of two artists. ▷ *Jan Kaila was born 1957 in Jomala, Finland. He has taught at the University of Art and Design Helsinki since 1984, and graduated as a Doctor of Fine Arts from the Helsinki Academy of Fine Arts. Currently he is working as professor of post-graduate studies at the Finnish Academy of Fine Arts.*

Jan Kaila

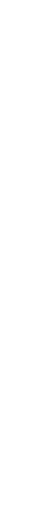

Untitled, 1988, 104 x 130 cm, lambda print

Jan Kaila

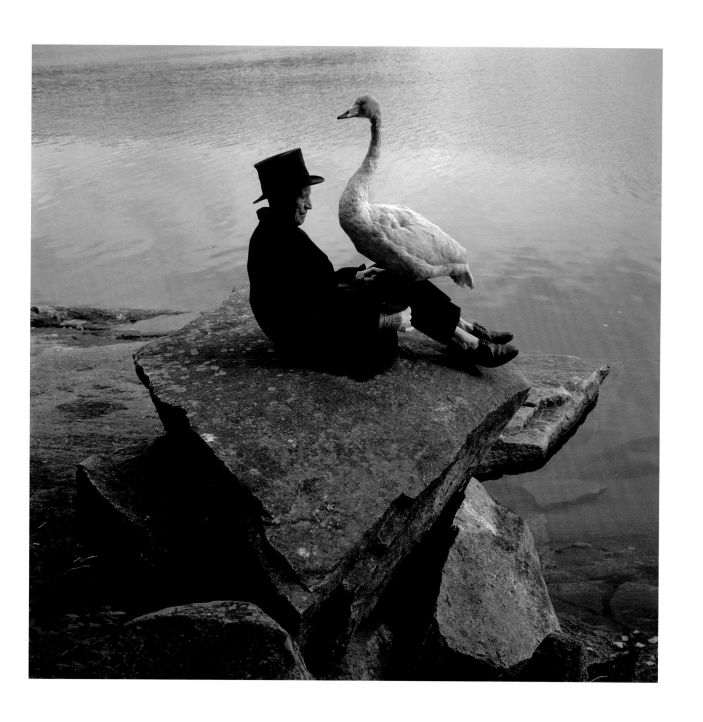

Untitled, 1989. 120 x 120 cm, lambda print

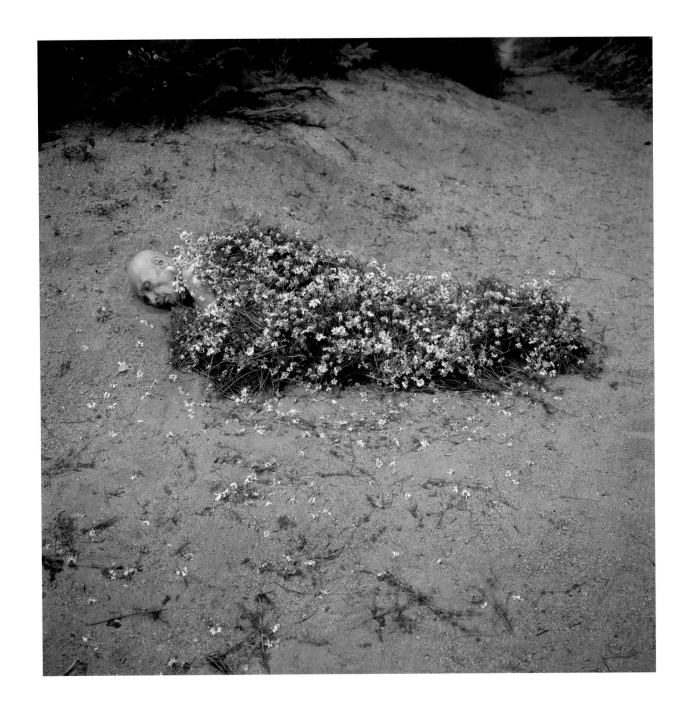

Untitled, 1989, 127 x 127 cm, lambda print

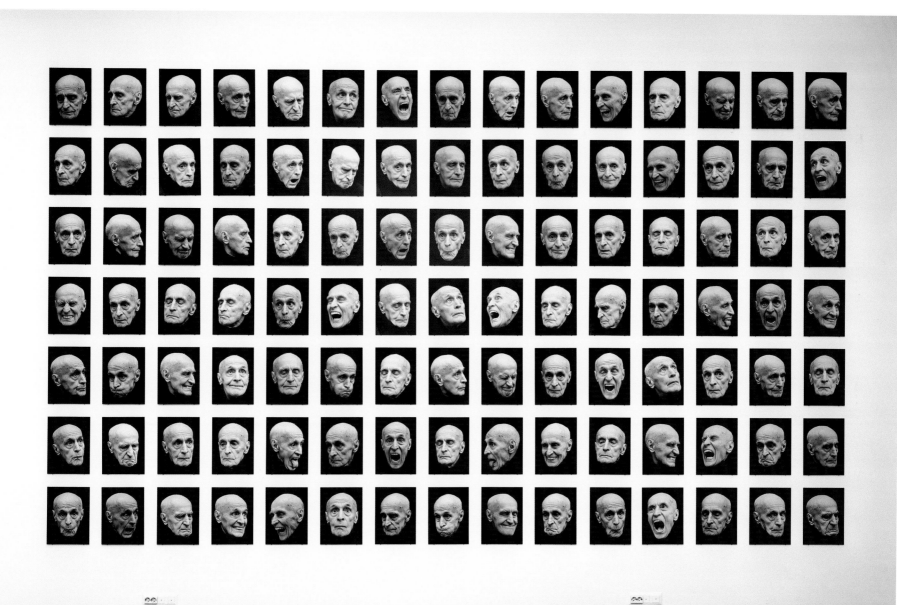

Jan Kaila

Installation view of *I Am Different every Moment*, 2000, dimensions variable, each photo 50 x 40 cm, lambda print. Installation photo taken by Juha Nenonen

Joakim Eskildsen's work is based on the theme of the relationships between man, nature, and culture. There is a clear documentary aspect…

…to his photographs. This approach can be related to the works of the humanist photographers in the sense that his intent is not the scientific interrogation or exploration of his subjects, but the creation of an empirical record of his encounters with various peoples and cultures. Submerging himself in the worlds he wishes to explore, Eskildsen resides for extended periods of time with the people he photographs. He thus develops a better understanding of their cultures and, in so doing, attempts to avoid the pitfalls generated by the simple, uninformed appropriation of their images. The photographs are presented as a story and are usually accompanied by the texts of Cia Rinne, a young Finland-Swedish writer who collaborates with Joakim Eskildsen on most of his projects.

Eskildsen's recent series, entitled The Roma Journeys, concentrates on Roma cultures. It was begun in January 2000 in a street, on the edge of a small village in Hungary, where a group of local Roma lived. It was this encounter which sparked his interest in their culture and led him to travel in search of various different Roma groups. In 2001, he went to India and in 2002 to Romania and Greece. He has also spent time with Roma in Finland, France, and Russia.

▷ *Joakim Eskildsen was born in 1971 in Copenhagen, Denmark. He graduated from the University of Art and Design Helsinki in 1998.*

Joakim Eskildsen

Joakim Eskildsen

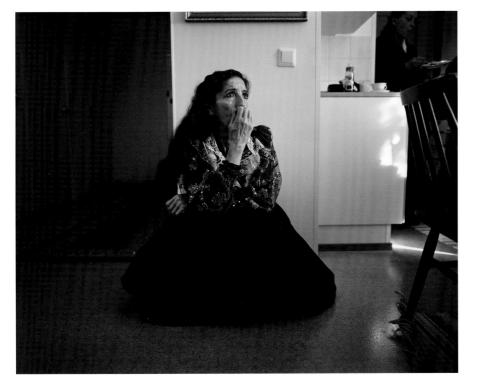

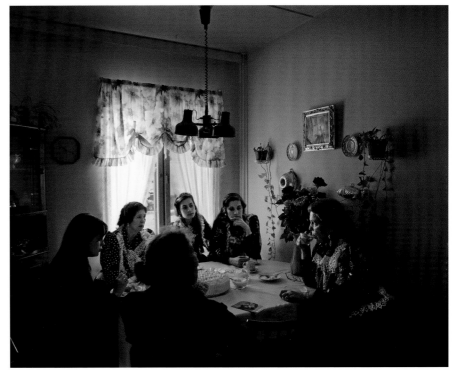

Säde Åkerlund, Kirstinmäki, Finland, 2006, 90 x 75 cm, archival ink print
Ramona, Rosa, Aila, Anse, Paula, and Sandra Åkerlund, Kirstinmäki, Finland, 2006, 90 x 75 cm, archival ink print

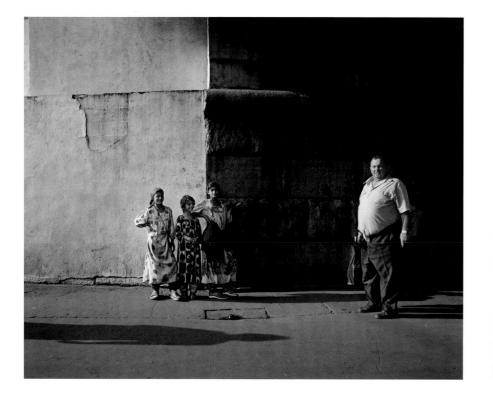

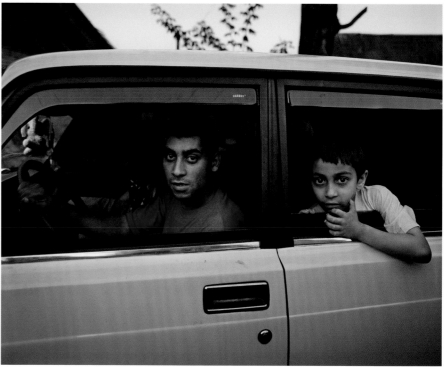

Zarina, Mardjina and Vulfira from Kolkhozabad in Uzbekistan, Moscow, 2004, 90 x 75 cm, archival ink print

In Kosaya Gora, Tula Oblast, Russia, 2004, 90 x 75 cm, archival ink print

Joakim Eskildsen

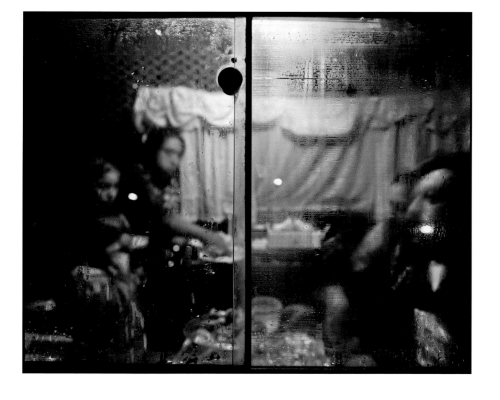

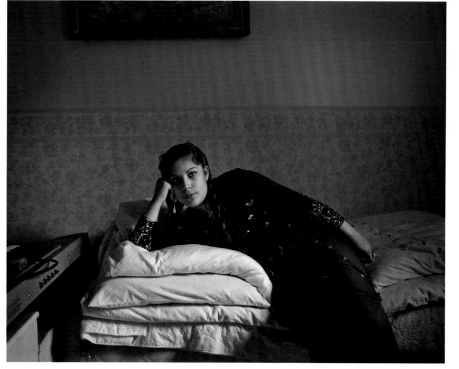

Cassandra, Anuta, Asmina, and Ionel Caldaras from Romania, Kaisaniemi, Finland, 2005, 90 x 75 cm, archival ink print

Tamara, Kaitaa, Finland, 2005, 90 x 75 cm, archival ink print

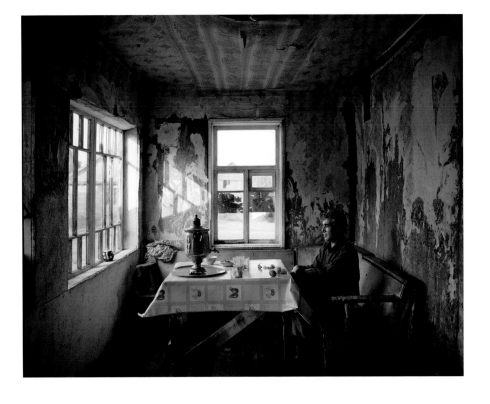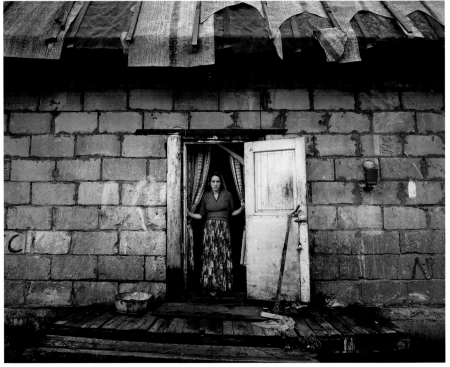

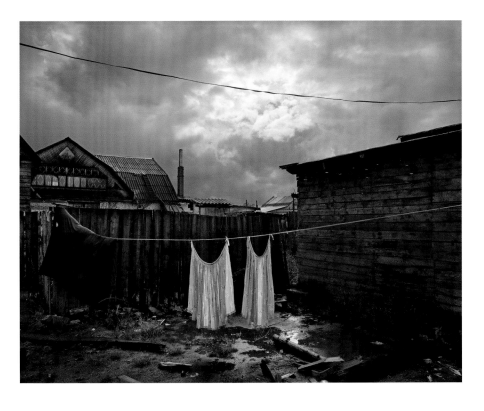

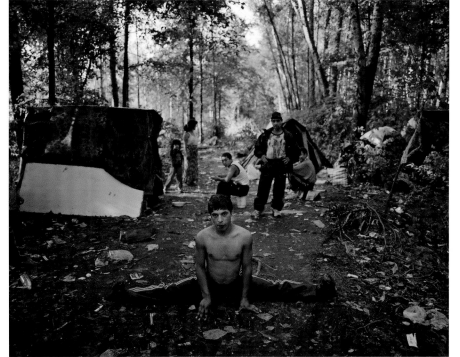

In Chudovo, Russia, 2004, 90 x 75 cm, archival ink print
In Obukhovo, Russia, 2004, 90 x 75 cm, archival ink print

Sandra Kantanen

Sandra Kantanen's work
is dealing with our perception
of the landscape….

…She first became interested in traditional Chinese landscape painting while still a student in Helsinki. On her first trip to China she was confronted by the contradiction between the idealized landscapes represented in China's long history of landscape painting, and the reality of modern day China, whose landscape has been drastically altered by unchecked economic development and environmental degradation. Coming from Finland, where the beauty of nature lies in the notion of wilderness untouched and "natural," Kantanen was confronted with a culture where natural beauty is idealized through arrangements based on aesthetic codes.

Kantanen developed her own method of printing. She conceived of a technique in which ink-jet printing is combined with acrylic paint on a thin metal plate. In this combination of painting and photography, the images are characterized by the unity of their subtle color tones. The painterly qualities of the work, as well as their sparse details, create a distance between the subject and the object, conferring an imaginary or ideal character to the landscapes.

In her new series, produced during a sailing trip across the Atlantic, she realized that she views landscapes as being artificial, man made, settings. This sense of artifice is embodied in her work through the use of the above mentioned technical process which lends her photographs a certain painterly appearance. ▷ *Sandra Kantanen was born in 1974, Helsinki, Finland. She graduated from the University of Art and Design Helsinki in 2003.*

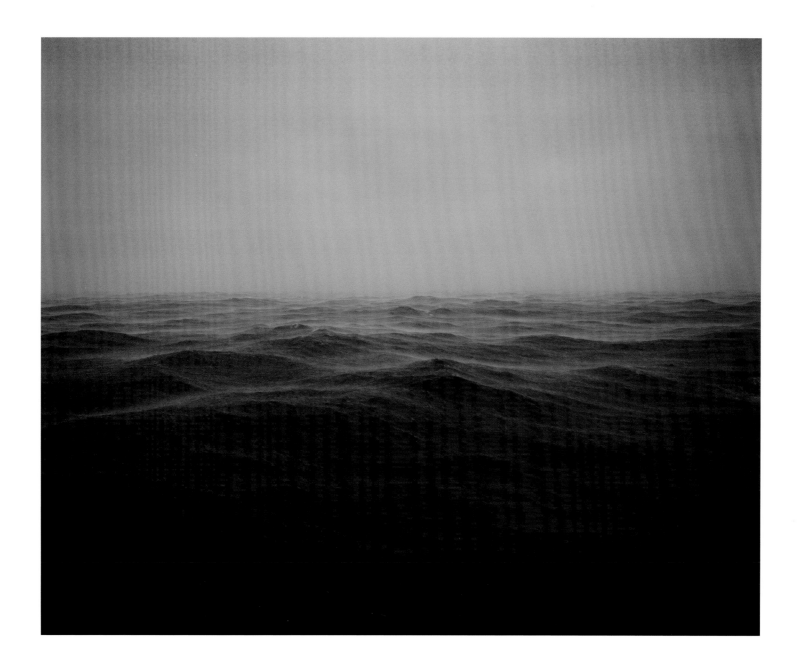

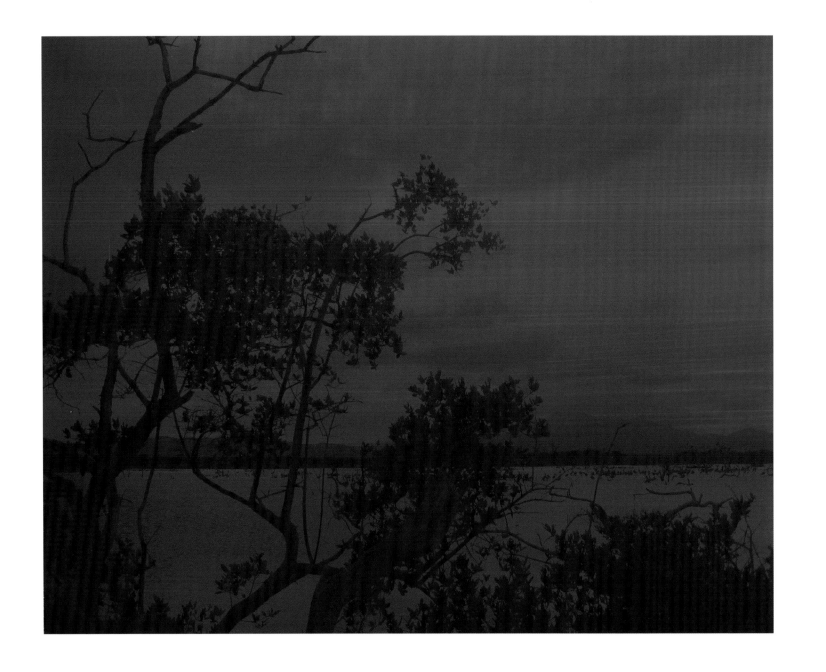

The swamp, 2006, 29 x 33 cm with frames, pigment print and ink on cloth

Sandra **Kantanen**

Tree in water, 2006, 34 x 33 cm with frames, pigment print on painted aluminum

Cloud, 2006, 34 x 33 cm with frames, pigment print on painted aluminum

Waterfall, 2006, 34 x 33 cm with frames, pigment print on painted aluminum

Arno Rafael Minkkinen
was born in Finland, then
immigrated with his
family to the United States in
the early nineteen-fifties.…

…The memory of the Nordic landscape and the northern light remained vivid in Minkkinen's mind and becamethe central source of his creative inspiration.

In combining elements of avant-garde performance with the more traditional theme of landscape, Minkkinen has developed a unique visual language to express man's relationship to nature. His black-and-white photographs are the records of these performances. About his artistic approach the artist states that "I consider myself to be a documentary photographer. If you see my arms coming up from under the snow, I am under the snow. I treat the medium the same way a street photographer does. What happens in front of my camera happens in reality. There are no double exposures, no digital manipulations."

In combining elements of avant-garde performance with the more traditional theme of landscape, Minkkinen has developed a very unique visual language to express man's relationship to nature. ▷ *Arno Rafael Minkkinen was born 1945 in Helsinki. He has taught at the University of Art and Design Helsinki, the Massachusetts Institute of Technology, the Philadelphia College of Art, the University of Massachusetts-Lowell, and at various European universities.*

Arno Rafael Minkkinen

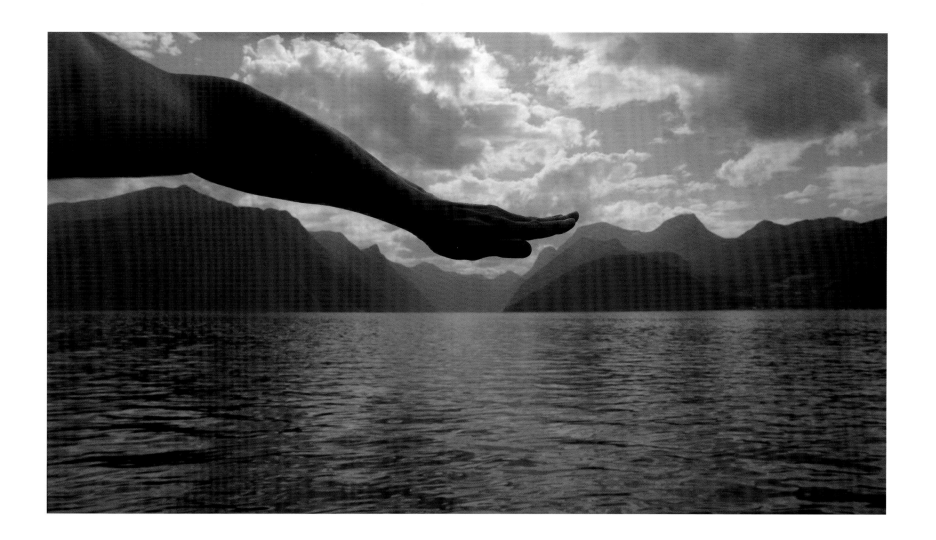

Stranda, Norway, 2006, 30 x 56 cm, silver gelatin print

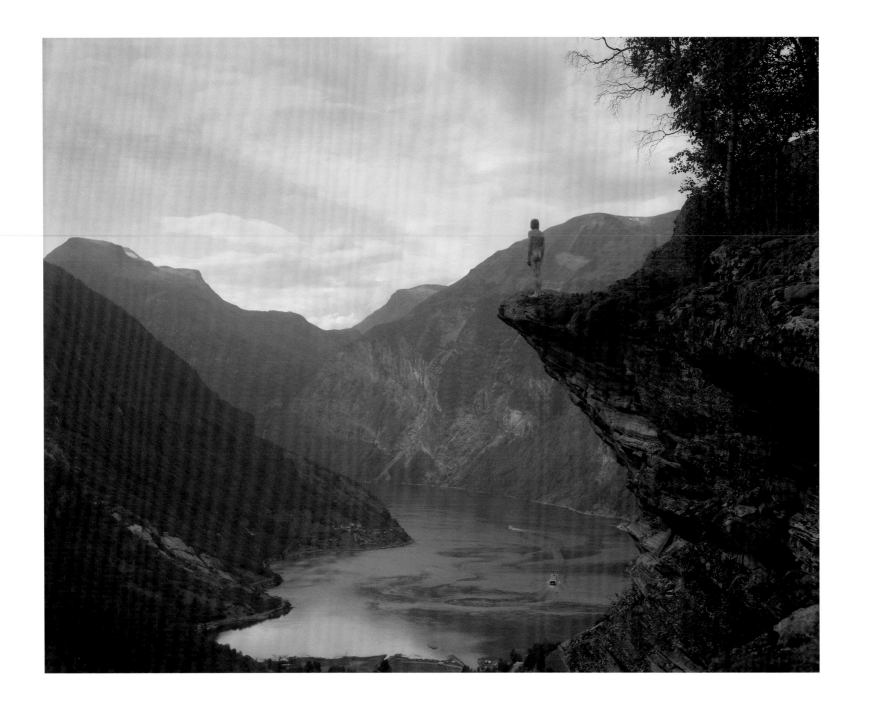

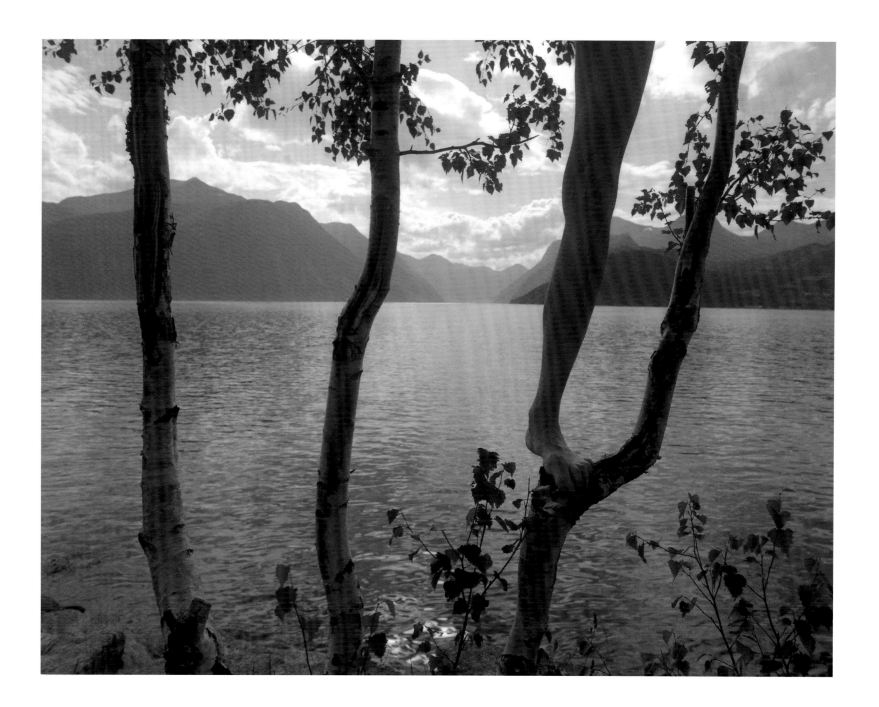

Stranda, Norway, 2006, 48 x 58 cm, silver gelatin print

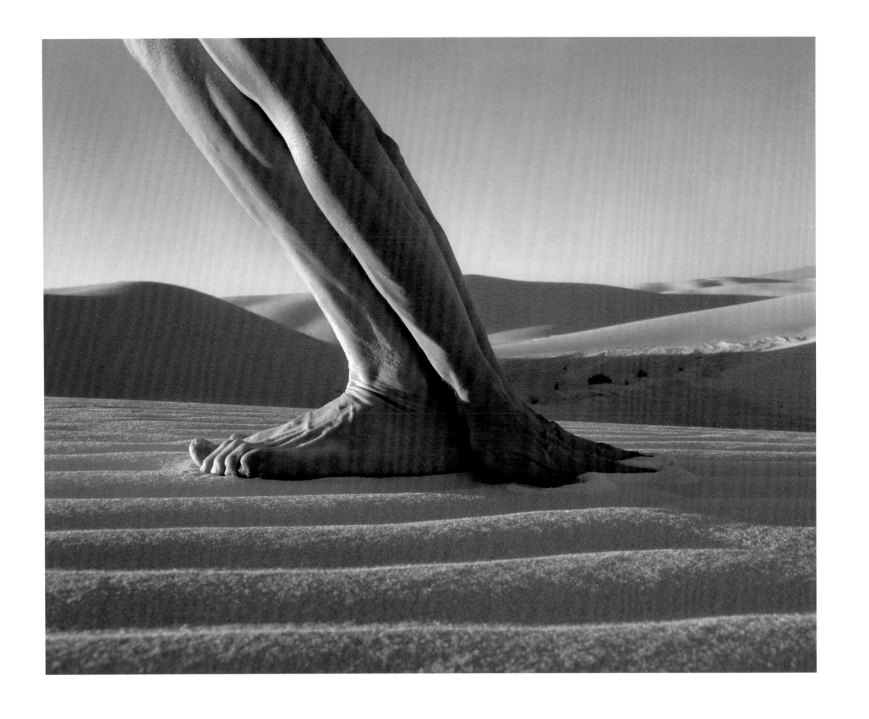

White Sands, New Mexico, 2000, 48 x 58 cm, silver gelatin print

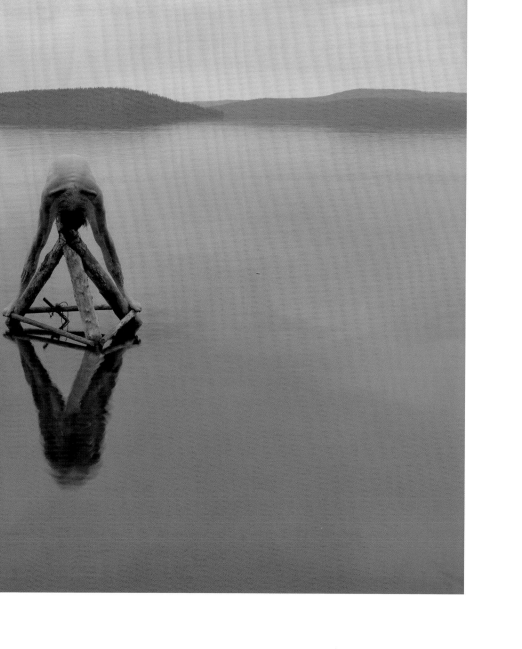

Arno Rafael Minkkinen

Ivalo, Finland, 1995, 48 x 58 cm, silver gelatin print

Interviews

with

Jorma Puranen
Ola Kolehmainen
Timothy Persons

by Andrea Holzherr

Jorma Puranen

What is your position at UIAH?

At the moment I work
as a visiting lecturer,
but I was working as
a professor at the
photography department…

…at the time when Timothy Persons started the Gallery TaiK. I supported his efforts when he went with the students for the first time to the Stockholm art fair, I think it was in 1996.

So, right from the beginning a spirit of collaboration existed between the photography department and Timothy Persons?

Yes, absolutely. Timothy worked at the department of ceramics but perhaps he felt that the photography department was more vibrant and that lots of good work was being produced there. As somebody coming from the outside he also realized that none of that work could be sold in Finland since there was no market for photography. This was also my opinion.

That was the time when photography indeed represented the Other of the visual arts in Finland. There was a lot of good work done in Finland at the end of the nineteen-seventies and in the eighties and even more so in the nineties that one could have shown anywhere. Outside of the metropolitan zones we just did not know how to get the works abroad and a lot of photographers were quite frustrated about the situation. It was in this context that Timothy suggested that we collaborate.

Timothy must have been totally convinced of the high quality of the photography department if he was willing to collaborate with you and start out on such an unusual enterprise.

I believe he was, he would not have taken the risk if he had not been convinced of the excellence of the students and the teachers.

How do you explain that UIAH supported Timothy Person's idea of placing students in the art market? I suppose that you agree that this is not really the role of a university?

Well, certainly this is not the most central role of any university. However, we will have to bear in mind that UIAH was in the process of reaching out and going international at that time. Very early on the university created an extensive exchange program, for example. The university invited not only students from all over Europe, but also teachers and professors. UIAH has invited quite a number of people representing different disciplines and practices in the photographic field from Martin Parr to Alfredo Jaar and from John Berger to Abigail Solomon-Godeau, just to mention a few.

In this context of internationalization we thought that it would be good educationally for students to get some experience of working and showing outside Finland. This is where Timothy's professional skills came into practice from preparing students for presenting their ideas clearly and professionally plus creating a long-term promotion strategy. The head of the university supported these new ideas and understood their educational value.

How do you explain the high standard of the photography department at UIAH? How is it that in the depressed context of the Finnish art market at the time, there developed such a high potential for good work?

I think we have a very good and supportive education system in schools and universities in Finland and that is quite crucial. There has also been a long-term public investment in photographic education. But this is not the only explanation. Another might be that the community of photographers in Finland is quite small, we all know each other, and we willingly give each other support; we also communicate readily between different generations. I have been around the Finnish photography scene for thirty years, but I can easily communicate with my students, we even exhibit together. It is a very democratic system.

Finland also has a very supportive grant system which helps the artists to travel and to produce their work. Institutional support also includes bodies such as FRAME, the Finnish Fund for Art Exchange, that helps visual artists showing abroad.

When did you begin as a professor at UIAH?

I have worked as a teacher for most of my professional life. In fact, three or four years after graduating, I began teaching at UIAH from which I myself graduated. Then during ninetees I worked as a professor of the university for a few years.

Interesting, and who were your teachers there?

One of them was Ismo Kajander and another Arno Rafael Minkkinen. See, a very interesting situation was created when Minkkinen came from the U.S.A. in order to teach in Finland. I wouldn't say it had the effect of a bomb, but still, the way of thinking about photography he brought with him into our world was unusual and very new to us.

Pentti Sammallahti was also a very influential person to me, even if he is only a couple of years older than I am. Pentti's role in the seventies and eighties was very crucial. He went to great lengths for you if he considered your work interesting. He did not spare any efforts. He even spent a lot of his own money to support students.

I saw that he is the founder of the Opus *portfolios.*

Yes, he is. He is the one who set the standards of black-and-white printing in Finland. Pentti studied the different printing techniques, he bought books on the topic in the United States, and he proceeded in doing real research in the field. There was nobody in Finland who had his skills and his knowledge! He was the first in Finland to do proper and competent duo-tone printing. He is very skillful and a wonderful person.

So, teachers were instrumental in the development of the photographic scene in Finland?

Yes, and in many ways, working as artists and working as educators. This system has been very supportive, with very little competition so far and a lot of good help. It was a very productive context.

What is your definition of the Helsinki School?

I think it is a movement in progress. It is not a closed group of people, it constantly moves on. New people who may have something to share are joining every year, people who once graduated from the university or worked there as teachers. What is good about the Helsinki School is that it avoids any closed definitions of what it is. It hopefully works as an arena for an exchange of ideas, suggesting conversations to take place.

Does the Helsinki School have anything in common with the Becher Schule in Düsseldorf?

Düsseldorf Art Academy has almost become a myth. But basically the framework and structure of these two educational institutions seem to have much in common. There are a lot of differences, one of them maybe is that in the Helsinki School there are a lot of teachers involved, no single person has been, or is, more dominant than the others in the education of the students.

We do not emphasize one given attitude or educational formula. Rather we aim to understand every single student as personally different and trying to support their individual personal growth and development from their own point of departure. What also makes us different is that we practice a plurality of approaches and disciplines. This, for me, is also what really defines the Helsinki School.

How do you explain the international success of the Helsinki School?

For me as an insider it is sometimes difficult to see the whole picture. Beyond hard work and determined efforts there must be something about the quality of the work itself. But also of a certain localness, or cultural identity. It looks as if it is now possible for an artist to maintain a local context and participate in international dialogues.

I hope that there is something which differentiates us from other photography scenes and that this might be seen in our work. Perhaps this difference is somehow related to our success.

What, in your opinion, is this difference or "Finnishness"?

This makes me wonder of how relevant it is to think of art or photography in terms of cultural differences or to position oneself entirely within the national narratives. You hardly ask an artist living in France about her or his Frenchness. Yet, even if the photographs are discovered or constructed, I would say that there is a kind of a spirit that runs through the different approaches. Take for example Aino Kannisto's work which is very different from the work of Esko Männikkö; but somehow in her work you find the same performative "slowness" as in Esko's work. For me this could be the result of a certain meditative spirit, a cultural difference.

One way of locating Finnishness might be trying to trace poetic possibilities found in *silence*.

Ola Kolehmainen

What is your relation to UIAH?

I graduated from UIAH
in 1999 and oversaw
a couple of workshops
there before moving
to Berlin in 2005….

…But I am still connected to the scene and I still work with Timothy Persons and Gallery TaiK.

What was Jorma Puranen's role as a teacher at UIAH?

The role of Timothy Persons in the Helsinki School movement is obvious, but there is one professor who was also very important in the development of the movement and that is Jorma Puranen. I was still a student when Jorma came to the department as a professor. He was not only our artistic director but he also gave a huge amount of his energy. He is a very encouraging person and his role was very important in the beginning of the movement. I do not know if it could have happened without him. In fact there are three important people that have contributed to the Helsinki School, the director of the University, Yrjö Sotamaa, Timothy Persons, and Jorma Puranen. I think if you would take one of them out, the movement would have been quite different or even inexistent.

How do you explain the relatively high number of good photographers in the photography department at UIAH?

I think it has to do with the quality of the teaching at the university. A lot of good photographers in the country did not choose to leave in order to make their careers abroad but stayed in Finland and became teachers. So when Timothy Persons started Gallery TaiK, there were already lots of interesting artists who just needed a platform to present their work.

What is your definition of the Helsinki School?

Gallery TaiK gave us young photographers the possibility to show our work in Europe, in a way that did not exist before. At the time of the initiation of Gallery TaiK, in 1995, there was no such thing as the Helsinki School. This name was coined later on. It is the name for a group of people who, for the most part, graduated from the photography department at UIAH. We all work in the same medium but in completely different ways. These people are united in the Gallery TaiK which represents them. With the creation of the Helsinki School exhibition the name somehow became institutionalized.

You are one of the photographers who participated in the Helsinki School exhibition, can you tell me a little more about this exhibition?

The Helsinki School exhibition was curated by Timothy Persons in collaboration with Jorma Puranen and opened at the Finnish Museum of Photography in Helsinki in summer 2005. Since then it has been touring in Europe, where it went to major cities like Berlin, Brussels, Prague, etc. The exhibition features the work of a maximum number of professors and students of UIAH.

One very strong element in the exhibition is the fact that it is in constant evolution; older works of the exhibiting artists are con-

stantly replaced by newer ones. This keeps the exhibition fresh and unique but it is also a challenge for the participating artists who have to keep their production up to the standards of an always new exhibition. This way, new and young photography students from the department are able to participate in the exhibition and the ones already participating have constantly to revise their work.

How do you explain the international success of the Helsinki School?

One reason is because the work, when it arrived on the art market, was new and fresh and of good quality. This created a certain surprise. The other reason is the personality of Timothy Persons who is exceptionally gifted in promoting the work of the photographers. He is very well connected, he is a very gifted mediator, and he is willing to give all his energy to this project. There are very few people like him in the art world. The success of Gallery TaiK was not planned, it was wished for but when we started we never imagined that we could have such a success. And this success generated the motivation and the energy for the photographers to do more and better work. And through the sales the photographers also earn the money they need to produce new work and to keep up with the technical standards of photography.

Ola, in 2005 you moved from Finland to Berlin, why?

For many years now I wanted to leave Finland and a few years ago, I fell in love with Berlin. But I had already lived abroad before, I had a residency in Paris, another one in Brussels, and I always traveled a lot. The reason to move from Helsinki to Berlin was that in my photographic production, I had only one picture which was taken in Finland. I find my motivation abroad and it is much easier for me to work and travel in Central Europe. Also, Finland is unfortunately on the periphery of the art world while Berlin is a place where a lot of things are happening right now in the visual arts. Many professionals come to Berlin and thus creating networks is much easier. Curators, art critics, art historians are much more present in Berlin than in Helsinki.

Timothy Persons

*For how long have you
been a teacher at UIAH?*

My first experience with
the university was
as a visiting lecturer in 1982.
My original plan was
to stay six months…

…and then go back to Los Angeles. However, I stayed and worked for two more years in Finland. In the fall of 1984 I moved to Sweden and taught there for six months. Then I came back to Finland again and started to teach exclusively at the academy of fine arts for four more years. I finally went back to UIAH in the nineties.

This was in fact an interesting moment because UIAH's director Yrjö Sotamaa knew that if he wanted to keep the university on an international level, he had to do something radical. He knew that there was talent, but that they had lost a certain momentum. Martin Parr, Sally Man, Arno Rafael Minkkinen, and many other important photographers had come to the school in the late nineteen-eighties to teach and to do workshops but then, in the nineties, everything just stopped with the recession. I came back in the deepest hole, in 1994. Yrjö Sotamaa asked me to review the different programs and to see which one had potential, which ones did not.

So you came back as an adviser, not as a teacher?
I returned to UIAH as a teacher and as an adviser.

And how did you go about dealing this problem?

When I came back to the university in 1994, I started working with all the departments, and soon thereafter with Jorma Puranen. You have to remember how things worked in those days. None of the students had a portfolio, maybe a manila envelope with some contact sheets or maybe some poorly printed A4 prints.

It was then, that we laid out the teaching standards, and the students of that generation were the first ones to benefit from it. The group was composed of Jyrki Parantainen, Ola Kolehmainen, Mariana Kella, amongst others. Elina Brotherus was the youngest of that generation. They were really eager to learn and I saw the talent of that group. I had long discussions with Jorma and the director of the school about what to do and how to do it.

Was that the moment when the idea of Gallery TaiK took root?
About ten years ago Finland was coming out of a big financial recession. There was no money for culture and there were practically no galleries. The university lacked a defining image. I examined the university for about a year to see what could be done and realized that the gallery space that the university used in the city was not worth the money. First of all, the shows presented there were terribly uneven. There was no director, they couldn't sell anything, and they couldn't pay the rent! It represented a yearly loss of nearly 100,000 Finnish marks. So I decided to take that money and use it for other, more strategic things like going to international art fairs, creating books and publications, and giving individual grants to students' projects. It was a gamble and I had a lot of critics but it worked! I invented Gallery TaiK as a means of presenting the Uni-

versity of Art and Design. The way we started Gallery TaiK during the recession was that we found these fantastic empty spaces in the city center that were either for sale or for rent. We would take one such space every season and change it into a gallery. The students did all the work, everything was done internally. The students painted the walls, did the hanging and the lighting in a very professional manner and the shows looked great. Eventually catalogues were produced. We did these shows for six weeks and then moved on to another space. Then we started doing the art fairs and we traveled abroad under the name of Gallery TaiK.

So you started by exhibiting the generation of Ola Kolehmainen and Jyrki Parantainen?

Yes, that's right. It actually took us a few years to get to a professional level. TaiK, as a virtual gallery, was conceived as a platform to get the artists out of Finland. What I was doing was taking the class out of the classroom. Stockholm was our first experience and it worked better than we could have even imagined. Not only was the fair a place where the students could present their work but, as I would take the students with me, it was also a way of opening up their horizons. Furthermore, by forcing them into a professional way of presenting their work with portfolios, press kits, statements, etc., I also forced them to think about what they were doing.

Before going to Stockholm we had never really thought about success. It was rather an experiment, we had thought "let's do this and see what will happen."

And your success in Stockholm gave you the necessary courage to go further with your idea?

Yes absolutely! After our success in Stockholm we brought Gallery TaiK to Berlin. We started very small, twenty-four square meters. The principle we had right from the beginning was that we decided not to compromise. Anyway, nobody would sell this work in Finland, so why should the students compromise with their work.

When you started to go international, what was your main aim?

The main aim at first was to find galleries for the students because they couldn't find any at home. I took them abroad so that they could gain exposure to a wider audience and, in a sense, be ambassadors for the university, but also for Finnish art. Esko Männikkö is a good example. He started showing with gallery Nordenhake in Berlin. By the time he acquired an international reputation we already had the next group of photographers ready with Elina Brotherus, Ola Kolehmainen, etc. … and they, in turn, became very strong. The idea was to use each generation of students to pave the way for the one that was coming next; they have the space to grow up and don't have to follow the format of the former group. The university has a policy to support the students financially and technically even years after their graduation. We give these post graduates a chance; we don't close the door on them! We got a lot of criticism for that but it worked! We have the proof in that we are now bringing up the fourth generation. Much of the merit for the success of this program goes to Yrjö Sotamaa, the director of the university. He is a real visionary. For him it is not enough to be the best art school in northern Europe, he wants to compete on a world wide scale! A lot of it hinges on me because I am the one who has the international contacts, and because I am also an independent curator, I can get the students into shows they would normally not get into.

How do you explain the high number of good photographers among the students at the school?

The reason is multifaceted but the key is the presence of Jorma Puranen as a teacher, he insisted on theory as much as on technique. A number of other teachers at the school studied with Puranen and in turn transmit his insistence on theory to their students.

How did you manage to sustain that quality over the years?

This was a very crucial question to solve! After our success in Stockholm and Berlin, we had to build for a new generation of students. That meant that somehow we had to take the people from the second generation and bring them back to the university as teachers. This way the bloodlines were closer to the new source. The secret that I see is that there is a lot of experience in these older generations, we just have to utilize that knowledge and give it a voice so that the following generations can blend it with their own, and then share it with the next one. The blending is a very important thing. The reason why we could do that was that we were such a small group.

So what is this famous Helsinki School?

The Helsinki School got its brand name when somebody asked me how to call this group of photography students and I responded, "Well … I don't care … call it Helsinki School." The Helsinki School is linked to the University of Art and Design in Helsinki, which created this project in the first place, supported us right from the beginning, and is still very much committed to it.

What are the plans for the future?

How I see it is that we nurture this fourth generation I am working with right now. I have not changed our approach and what is important is that we are continuing to maintain the level of quality we had right from the beginning.

You can't predict how long something is going to last. All you can do is to give it the necessary effort, and that effort is daily. I dedicated my life to this project and I truly believe in what I am doing.

What about the new gallery space in Berlin?

The reason I moved Gallery TaiK to Berlin a couple of years ago is that I believe in Berlin as a place of cultural crossroads between Scandinavia and Europe and between Europe and the rest of the world. I use Berlin the way I started to use the art fairs, as a way to open the doors for Finnish photographers.

So in fact for you Berlin is the follow-up of the art fairs.

Yes, in a way it is like going back to the roots when we began investing spaces and producing shows. I am using Berlin as a showroom for the works of the very young students. We are not yet taking these young artists to the art fairs, but the Berlin space is a good platform for them and in this way they get good exposure. And, right from the beginning, the Germans have been a very good and very interested audience. When we first presented our students in Berlin, the label Helsinki School did not exist but the Germans were already interested in what was coming from the North. They understood that there was something fresh and different. The Germans were indeed my first allies. Now I have been in Berlin long enough to know people there, curators and collectors, and I am myself a Berliner!

Acknowledgements

University of Art and Design Helsinki
Korjaamo Culture Factory
The Ministry of Education of Finland
The Ministry of Foreign Affairs of Finland
Dr. Pentti Kouri
Janne Kouri
FIM
European Art Projects
Paris Photo
Onerva Utriainen
Eeva Berglund
Eero Anhava

For updated artist information please see
www.thehelsinkischool.com

Coordination
Claudia Stein, Photography now, Berlin
Eero Anhava, Korjaama Culture Factory, Helsinki

Authors
Andrea Holzherr, Paris (Artist introductions, interviews)
Timothy Persons, Helsinki

Copyediting
Ingrid Bell, Basel

Concept, graphic design, and typesetting
Claudia Stein, Photography now, Berlin
Margarethe Hausstätter, ExtraGestaltung, Berlin

Image editing and production
hausstætter herstellung, berlin

Typeface
Imago

Paper
170 g/m² Maxi Satin

Binding
Kunst und Verlagsbuchbinderei Leipzig

Printed by
Dr. Cantz'sche Druckerei, Ostfildern

Published by Hatje Cantz Verlag
Zeppelinstrasse 32, 73760 Ostfildern, Germany
Tel. +49 711 44 05-200, Fax +49 711 44 05-220
www.hatjecantz.com

Hatje Cantz books are available internationally at selected bookstores
and from the following distribution partners:

USA/North America – D.A.P., Distributed Art Publishers, New York, www.artbook.com
UK – Art Books International, London, www.art-bks.com
Australia – Tower Books, Frenchs Forest (Sydney), www.towerbooks.com.au
France – Interart, Paris, www.interart.fr
Belgium – Exhibitions International, Leuven, www.exhibitionsinternational.be
Switzerland – Scheidegger, Affoltern am Albis, www.ava.ch

For Asia, Japan, South America, and Africa, as well as for general questions,
please contact Hatje Cantz directly at sales@hatjecantz.de,
or visit our homepage at www.hatjecantz.com for further information.

ISBN 978-3-7757-1888-2

Printed in Germany

Cover illustration Susanna Majuri
Back-cover illustration Noomi Ljungdell